Tony Oursler

a cura di
edited by
Simona Lodi

CHARTA

Progetto grafico/Design
Gabriele Nason

*Coordinamento
redazionale
Editorial coordination*
Emanuela Belloni

Redazione/Editing
Elena Carotti

Impaginazione/Layout
Daniela Meda

*Ufficio stampa
Press office*
Silvia Palombi Arte &
Mostre, Milano

Realizzazione tecnica
Amilcare Pizzi Arti
grafiche,
Cinisello Balsamo

*In copertina/Cover
Digital*, 1997

Referenze fotografiche
Roberto Marossi
Metro Picture Gallery,
New York

Questo volume è stato
realizzato in
collaborazione con ACP
SEI in occasione della
mostra di Tony Oursler
alla Galleria 1000eventi
di Milano, 15 gennaio -
20 febbraio 1998

This book has been
realized in collaboration
with ACP SEI in the
occasion of the
exhibition of Tony
Oursler at Galleria
1000eventi, Milan,
15 january - 20 february
1998

Edizioni Charta
Via della Moscova, 27
20121 Milano
Tel.+39-2-6598098/6598200
Fax +39-2-6598577
e-mail: edcharta@tin.it

Printed in Italy

Galleria 1000eventi
Via del Lauro, 3
20121 Milano
Tel.+39-2-8053930
Fax +39-2-8053923

ny
°o sler

Sommario
Contents

Empathy, Mutation, Audience

Simona Lodi

Empathy, Mutation, Audience: lo spazio delle installazioni di Tony Oursler è strutturato in elementi che corrispondono all'empatia-partecipazione, ovvero alla trasposizione nell'oggetto estetico di sensazioni organiche, e al tentativo di mutare la vita psichica in realtà esterna, fino a rendere strutturalmente l'oggetto artistico adatto a lasciarsi percepire emozionalmente da un pubblico-audience di spettatori.

Bambole, fantocci o marionette, diversi sempre tra loro, da soli o in gruppi, con corpi imbottiti e teste ovali o schiacciate o ridotte a segmenti su cui vengono proiettati volti a cristalli liquidi, in ambienti domestici stravolti, ma riconoscibili, dal 1992 compongono le video installazioni di Tony Oursler. Queste installazioni possono sembrare un sistema che elabora tre tematiche principali, ognuna funzionale alle altre: l'individuo, l'interazione sociale e i mass media. In questa analisi l'individuo non è considerato un elemento primario, determinabile e conoscibile allo stato isolato, fuori dal sistema di relazioni che intercorrono, tra gli elementi umani, sociali e tecnologici-massmediatici. In questo contesto gli eventi umani sono considerati alla stessa stregua degli eventi naturali, osservabili dall'esterno, in modo da tralasciare le prospettive soggettivistiche e individuali. Dunque il soggetto risulta essere il punto casuale d'intersezione delle strutture sociali e mass mediali che lo attraversano. Pertanto, nelle opere di Tony Oursler, viene analizzata la diffusione dell'immagine del mondo reale attraverso i media: questa diffusione presuppone l'esistenza di una struttura, in cui la relazione logica tra gli elementi precede i suoi termini, così come la forma precede il contenuto.

Queste installazioni rappresentano un sistema semplificato del reale e servono a indagare il meccanismo che lega i mass media con tutta la gamma dei disturbi psicologici e sociali e con l'incremento dei crimini violenti. Come nella maggior parte dei sistemi le informazioni, che nutrono il sistema stesso, giungono a ciclo continuo e, intensificandosi, diventano a ogni passaggio più selezionate e distorte. Tenuta come costante per analizzare il campo fenomenico del sociale, questa immagine distorta, che i media esercitano come effetto della nascita dell'immagine personale, dei tipi fisici e dei bisogni, ha costituito un campo fertile per i lavori di Tony Oursler.

Negli Stati Uniti sono stati compiuti molti studi e sono stati fatti molti dibattiti sugli effetti della rappresentazione della violenza e del sesso in televisione per dimostrare alcune correlazioni con l'incremento dei crimini violenti, soprattutto tra gli adolescenti. Tutto questo suggerisce l'esi-

stenza di una relazione molto più complessa del semplice rapporto causa-effetto, che dunque attribuisce alla capacità dei media un potere di guida delle abitudini della gente.

Dagli anni Settanta molti artisti, ispirati dal concettualismo, allargarono la loro pratica estetica a sperimentazioni con performance, video, musica e altre forme non tradizionali, per muoversi fuori dal consueto mondo dell'arte. In questo ambito come sostiene per esempio Rosalind Krauss[1] "il genere di teatralità che si può trovare nel lavoro di Oldenburg, Morris e Nauman è fondamentale per la riformulazione del progetto scultoreo: cosa è l'oggetto, come lo conosciamo e cosa vuol dire conoscerlo. (...) E nel tentativo di scoprire che cosa è la scultura, o cosa potrebbe essere, si è usato il teatro e il suo apporto con il contesto dello spettatore come strumento di distruzione, di investigazione e di ricostruzione". Con i manichini antropomorfi in gesso di George Segal, o quelli impagliati con un orologio al posto della testa come *The Beanery* (1965) di Edward Kienholz, ci si spinge verso l'ideazione di forme d'arte che superino i confini dell'oggetto scultoreo per approdare alla ricostruzione di ambienti "al vero" e totalizzanti. Le installazioni di Tony Oursler oltrepassano gli ambienti di Kienholz, le performance e le scenografie teatrali, creando sintesi unificanti tra opere in video, sculture e installazioni ambientali.

I primi lavori di Tony Oursler consistevano in video di media durata, che si trasformarono a poco a poco in sperimentazioni sulla simultaneità e sulla frammentazione delle immagini. In *The Loner* (1980), *Spin Out* (1983), o *Evol* (1984), tutte dei primi anni Ottanta, allontanandosi dalla ripetitività dei film strutturalisti, veniva dato risalto al suono, che arrivava ad avere un'impronta estremamente ossessiva e vociante, in modo da abbattere la sequenza temporale e rendere il tutto così denso da farlo sembrare un'immersione nella mente di qualcuno. L'attenzione veniva posta nel cercare una decostruzione delle immagini dello schermo, dei suoi rituali e di come si riconnettono alla psiche. Tuttavia nei lavori successivi questo modo di procedere a poco a poco viene tralasciato da Tony Oursler facendo cadere la linea della decostruzione per perseguire lo studio degli stati emozionali. Trattare come struttura portante gli aspetti emozionali del linguaggio, fino ad arrivare a farli diventare gli aspetti totalizzanti dell'opera, significa non attingere dagli stereotipi o dagli effetti speciali di una certa filmografia, ma anche differenziarsi dalla mimica di un *performer*, per arrivare a produrre un linguaggio che potrebbe appartenere a un differente piano di realtà. L'ossessione della cultura postindustriale per la violenza e per il sesso risulta essere una strana forma di raffinatezza che lascia stupiti per i risvolti psicologici che ha sulla gente.

La progressiva espressione di sentimenti legati a questo atteggiamento di paura o di nevrosi si sviluppa nel lavoro di Tony Oursler attraverso la stesura dei testi che accompagnano il suo lavoro. La pratica dello zapping televisivo, spesso ripetuto per ore da ogni spettatore e a cui nessuno sembra riuscire a sottrarsi, crea un bombardamento di suoni, rumori e parole che agiscono sovrapponendosi ai pensieri personali, fino a non far distinguere più la propria voce interna, il flus-

so di coscienza, dal flusso di suoni televisivi. I testi utilizzati da Tony Oursler nei suoi lavori risultano scritti con l'applicazione di questo metodo e come conseguenza dei suoi interessi verso la MPD (Multiple Personality Disorder), cioè i disturbi della personalità multipla e del supporto che questo studio considerato in senso metaforico porta alle vittime di casi estremi di traumi psicologici, sessuali e di violenze.

In *The Flock* (1996) figure sedute, alcune grandi e altre piccole, parlano tra loro, interagiscono in vari modi con voci diverse ma sempre per creare un gruppo. L'effetto è dato da un sistema di collegamento tra queste figure di taglie differenti che proietta simultaneamente sullo schermo volti di altrettante taglie differenti, con voci diverse ma sempre della stessa attrice, in modo da rendere l'idea di personalità dissimili che ronzano nella mente di un solo individuo. La dissociazione è un meccanismo inconscio di difesa con il quale una parte di attività mentale esce dal flusso principale di coscienza separando la propria attività dall'unità centrale.

In *Blue/White State* (1997) il personaggio che prende parte all'installazione ri-racconta il trauma che ha causato la dissociazione: Pain, Fear, Anger and Memory. Tutte queste personificazioni prendono parte al teatrino surrealista che mette in opera un ambiente domestico tanto più inquietante quanto più si avvicina a una ricostruzione probabile. Il pupazzo giace sotto una poltrona ribaltata e, in un balbettio talvolta confuso, recita la sua litania ossessiva ponendo in scena l'orribile dramma della propria vita. La possibilità di entrare nei drammi della vita altrui, di poter sbirciare nelle case degli altri esercita un'attrazione morbosa verso la scena che si guarda, come quando capita per caso di assistere a un incidente stradale o allorché un'esecuzione capitale viene trasmessa in diretta.

I progetti di queste video installazioni partono da un testo cui vengono poi adattate le sculture: quante devono essere e in che modo possono interagire tra loro. L'idea di introdurre delle sagome all'interno dei lavori è subordinato quindi alla scelta del testo, a cui segue la proiezione delle immagini video.

Le figure che compaiono nei primi videotape, attorno al 1989, compiono un balzo all'esterno, nello spazio fisico. Queste specie di spaventapasseri o pupazzi vengono trattati come sculture, ma nel momento in cui abitano lo spazio uscendo dallo schermo, nei lavori eseguiti prima del 1992, perdono gran parte del loro aspetto talismanico e non catturano facilmente la fantasia. Divenuti elementi totemici, portano con loro stralci di culture primitive, dove i problemi figurativi non sono influenzati da concetti estetici, tipici di società più complesse. Esplorare, nei primi lavori di questo tipo, le innumerevoli varianti della gamma di situazioni che questi manichini possono interpretare, da pure sagome fino ad assumere aspetti umani, orienta sul principio la scelta di Tony Oursler di non mettere loro la testa per non rendere le figure troppo statiche.

La scoperta del proiettore a cristalli liquidi permette a Oursler di scavalcare questa *impasse* e di infondere energia ai soggetti. Con questa tecnica iniziano a spuntare teste sui

pupazzi, che all'inizio mantengono una certa proporzione anatomica con il corpo, ma che a poco a poco, man mano che la parte di video diventa predominante, iniziano ad assumere una dimensione fuori taglia rispetto al corpo sempre più collassato. Tutto questo si può trovare per esempio nell'installazione F/X *Plotter The Watching*, presentata alla Documenta IX di Kassel nel 1992, dove le gambe e le braccia del pupazzo non sono facilmente distinguibili a causa dello svuotamento della sagoma. In altre opere il corpo passa in secondo piano, come in *System for Dramatic Feedback* (1994) in cui i fantocci sono ammonticchiati in modo informe.

In alcuni lavori, soprattutto i più recenti, Tony Oursler ha voluto eliminare completamente l'elemento corporeo dei fantocci per lavorare solo con parti di corpo, come la testa, gli occhi, la bocca. In opere come *Submerged* (1996) sono ancora visibili il volto e la testa, ma nella videoproiezione rimane solo un occhio proiettato su un globo in fibra di vetro dipinto. Stimolato da cambi rapidi di canali televisivi, il nervo ottico registra le stimolazioni retiniche trasmettendo a sua volta immagini al resto del corpo. Nel comune patrimonio visivo l'immagine dell'occhio risulta associato ai rettili, mentre la faccia, la bocca, la fronte, ossia la parte del volto attorno agli occhi, risultano più idonei a veicolare emozioni. Con *In/Out Out/In* (1997) il volto è diviso e proiettato in due parti separatamente: sono mezze facce trattate come sculture, che trasformano un volto in una forma immateriale, unendo all'aspetto visivo l'aura di una forma solida.

L'idea di questa progressiva frammentazione del corpo rappresenta la parte più inquietante del lavoro di Tony Oursler, che riesce a mantenere la messa in scena di un'emozione pur eliminandone gli strumenti narrativi, come il corpo e i corrispondenti aspetti fisici e psicologici che vengono veicolati dal corpo stesso. Talvolta il corpo sparisce del tutto come in *Talking Light* (1996) in cui la presenza fisica è stata ridotta a una luce o come in *Bull's Balls* (1997), dove una bocca biascicante frasi ossessive è proiettata su testicoli di toro conservati in formaldeide.

La flessibilità di realizzazione dei progetti di Tony Oursler crea la differenza con i procedimenti utilizzati per costruire una storia cinematografica. Si utilizza in entrambi i casi la macchina da presa, che dilata e amplifica lo scorrere del tempo all'interno dell'opera. L'opera di Oursler non comporta un'accelerazione ma una situazione inanimata, più vicina a quello che Nam June Paik chiama "scultura stanza-piena", per descrivere gli ambienti creati dall'opera, al contrario del cinema che produce una compressione di momenti per creare l'intrattenimento.

1. Rosalind Krauss, *Passages in Modern Sculptures (1977)*, The MIT Press, Cambridge (MA), 1981.

Empathy, Mutation, Audience

Simona Lodi

Empathy, Mutation, Audience: the space of Tony Oursler's installations is divided up into elements that correspond to empathy and participation. The transposition of organic sensations into the aesthetic object is to attempt to change the psychic life into external reality, to the extent of making the artistic object structurally suited to allow itself to be perceived emotionally by an audience of spectators.

Since 1992, Tony Oursler's video-installations have been composed of dolls, puppets and marionettes, all of them different, alone or in groups, stuffed bodies and oval heads or squashed and reduced to segments, onto which liquid crystal faces are projected, in distorted but recognizable domestic settings. These installations seem to be a system that elaborates three main themes, all of them closely related: the individual, social interaction, and the mass media. In this analysis, the individual is not considered a primary element, identifiable and comprehensible in isolation, outside the system of relations that exist between human, social and technological and mass media elements. Human events are considered in the same way as natural events, observable from the outside, in such a way as to leave out subjective and individual perspectives. The individual is thus the casual point of intersection of the social and mass media structures that pass through him. Therefore, the works of Tony Oursler analyze how the image of the real world is spread through the media, this process presupposes the existence of a structure, in which the logical relation between the elements precedes its definition, as form precedes content.

These installations represent a simplified system of reality, and serve to investigate the mechanism that links the mass media to the whole range of psychological and social disorders and to the increase in violent crimes. As in the majority of systems, information, which feeds the system itself, reaches us in a continuous cycle, becoming more select and distorted at every passage. Held as a constant to analyze the field of the social, this distorted image, which the media exert as an effect of the birth of the personal image, of physical types and of needs, has constituted a fertile terrain for the work of Tony Oursler.

In the United States there have been many studies and debates about the effects of the representation of sex and violence on television in order to demonstrate the connection with the rise in violent crimes, especially among teenagers. All this would suggest the existence of a relation that is much more complex than simple cause and effect,

11

which therefore claims that the media have the power to direct people's habits.

Since the 1970s, many artists, inspired by the Conceptual Art, have extended their aesthetic practice to experiments with performance, video, music and other non-traditional forms, to move outside the customary world of art. In this context, as Rosalind Krauss points out, "The sort of theatricality that can be found in the work of Oldenburg, Morris and Nauman is fundamental for the reformulation of the project of sculpture: what is the object, how do we know it, and what does knowing it mean? (...) And in the attempt to discover what sculpture is, or what it could be, the theater and its contribution with the context of the spectator as an instrument of destruction, investigation and reconstruction has been used."[1] With George Segal's anthropomorphic plaster-cast mannequins, or in Edward Kienholz's stuffed mannequins with clocks instead of heads, like *The Beanery* (1965), we move towards the creation of forms of art that go beyond the confines of the sculptural object and enter the reconstruction of "real-life", total environments. The installations of Tony Oursler go beyond Kienholz's environments, performances and theater sets, creating a synthesis of video works, sculptures and environment installations.

Tony Oursler's early works consisted in medium-length videos, which slowly turned into experiments on the simultaneity and the fragmentation of images. In *The Loner* (1980), *Spin Out* (1983), or *Evol* (1984), he moved away from the repetitiousness of Structuralist films and highlighted sound, which had an extremely obsessive, loud character, in order to demolish temporal sequence and make the whole thing so dense that it was like being immersed in someone's mind. Attention was placed on the attempt to deconstruct the images of the screen, its rituals and how they relate to the psyche. However, in subsequent works Oursler left aside this way of proceeding, abandoning deconstruction to pursue the study of emotional states. To treat the emotional aspects of language as a fundamental structure, to the extent of making them become the principal aspects of the work, means not drawing on stereotypes or on cinematic special effects, but also distinguishing one's self from the mime of a performer, eventually producing a language that could belong to a different plane of reality. The obsession of post-industrial society with sex and violence proves to be a strange form of refinement that astonishes due to the psychological repercussions it has on people.

The gradual expression of sentiments related to this attitude of fear and neurosis develops in the work of Tony Oursler through the drafting of the texts that accompany his work. The practice of zapping, which often lasts hours and which none of us seems to be able to avoid, creates a bombardment of sounds, noises and words which overlap with personal thoughts, to the extent that it is impossible to distinguish one's own internal voice, the stream of consciousness, from the stream of television noise. The texts used by Tony Oursler in his works are written by means of the application of this method as a consequence of his interest

in MPD (Multiple Personality Disorder), and the support that this study brings to the victims of extreme cases of psychological, sexual trauma and abuse.

In *The Flock* (1996), seated figures speak to each other, some large and some small; they interact in various ways, with different voices, but always to create a group. The effect is given by a system of connection between these figures of different sizes through the projection of faces of equally different sizes onto the screen, with different voices belonging to the same actress, to give the idea of different personalities that buzz around in the mind of a single individual. Dissociation is a subconscious defense mechanism with which part of the mental activity leaves the main stream of consciousness and separates its own activity from the central processing unit.

In *Blue/White State* (1997), the character who takes part in the installation re-narrates the trauma that causes dissociation: Pain, Fear, Anger and Memory. All these personifications take part in the surrealist theater that stages a domestic environment that is all the more disturbing in that it approaches a probable reconstruction. The puppet lies under an upturned armchair and, in a sometimes confused babble, recites his obsessive litany, bringing the horrible drama of his life to the stage. The possibility of entering the drama of other people's lives, of peering into other people's houses, exerts a morbid attraction towards the scene that we look at, as happens when we witness a road accident or when an execution is broadcast live.

The projects of these video-installations start out from a text to which the sculptures are then adapted; how many there should be and how they should interact. The idea of introducing profiles into the works is therefore subordinated to the text that the images follow.

The figures that appeared in the first videotapes, around 1989, perform a leap out into physical space. Before 1992 these scarecrow-like puppets are treated as sculptures, but as soon as they begin to inhabit space by leaving the screen, they lose much of their talismanic aspect and do not easily capture the imagination. Having become totemic, they bring with them extracts of primitive cultures, where figurative problems are not influenced by aesthetic concepts, which are typical of more complex societies. The exploration of the innumerable variations of the range of situations that these mannequins can perform, from pure outlines to more human appearances, in the first works of this type, initially leads Tony Oursler to give them no heads in order not to make the figures too static.

The discovery of liquid crystal projection allows Oursler to overcome this *impasse* and fill the subjects with energy. With this technique heads begin to appear on the puppets; at first they maintain a certain anatomical proportion with the bodies, but gradually, as the video element becomes predominant, they assume disproportionate size compared to the increasingly withered bodies. All this can be found, for example, in the installation *F/X Plotter The Watching*, presented at Documenta IX in 1992 in Kassel, where the arms and the legs of the puppet are not easily distinguish-

able because of the emptying of the outline. In other works the body becomes secondary, as in *System for Dramatic Feedback* (1994), where the puppets are piled up in a formless manner.

In some works, especially the most recent, Tony Oursler has chosen to eliminate completely the body of the puppet in order to work only with parts of the body, like the head, the eyes, or the mouth. In works like *Submerged* (1996), the face and the head are still visible, but in the video-projection only the eye remains, projected onto a painted fiber-glass globe. Stimulated by rapid changes of TV channels, the optic nerve records the retinal stimuli, and in turn transmits images to the rest of the body. In the common visual patrimony, the image of the eye is associated with reptiles, while the face, the mouth and the forehead, that is the parts of the face around the eyes, are more suitable for conveying emotions. With *In/Out Out/In* (1997), the face is divided and projected in two separate parts: half-faces treated as sculptures, which turn a face into an immaterial form, adding the aura of a solid form to the visual aspect.

The idea of this progressive fragmentation of the body represents the most disturbing part of the work of Tony Oursler, which manages to maintain the performance of an emotion despite eliminating narrative instruments, such as the body and the corresponding physical and psychological aspects that are conveyed by the body itself. Sometimes the body disappears entirely, as in *Talking Light* (1996), in which the physical presence has been reduced to a light, or in *Bull Balls* (1997), where a mouth muttering obsessive phrases is projected onto bull's balls preserved in formaldehyde.

The flexible nature of the production of the works of Tony Oursler distinguishes it from the procedures used for constructing cinema stories. The film-camera is used in both, stretching and amplifying the flux of time within the work. Oursler's work does not involve an acceleration but rather an inanimate situation, more like to what Nam June Paik calls "full-room sculpture" to describe environments created by the work, whereas the cinema produces a compression of moments to create entertainment.

1. Rosalind Krauss, *Passages in Modern Sculptures (1977)*, The MIT Press, Cambridge (MA), 1981.

Il video è come l'acqua

Simona Lodi, Tony Oursler

Simona Lodi: *Ci racconti come sei arrivato ad usare il video?*

Tony Oursler: Nel 1976 sono andato al California Institute for the Arts; allora ero un pittore e avevo strane idee sul progredire della storia dell'arte in rapporto al mio lavoro. Pensavo ad esempio di dover cominciare come fotografo realista e di dover perfezionare questa tecnica prima di poter passare all'astrazione. Come lungo le linee della progressione di Mondrian, questo era ciò che pensavo a quel tempo. Ero molto attratto dai Surrealisti. Tornato nella mia città natale, Nyack, New York, avevo incontrato Robert Breer, il famoso animatore e artista, padre di Sophie, una donna a cui ero molto legato. Mi fece vedere alcuni film suoi e di Pat O'Neil e fui travolto dalla possibilità di immagini in movimento che diventano arte. Insomma, in qualche modo mi ritrovai di nuovo in California a studiare con alcuni artisti della prima generazione dei Concettuali, quelli che avevano l'idea che la forma seguisse il contenuto. In altre parole la loro filosofia era che gli artisti si dovessero concentrare più sulle idee che sull'abilità, che invece era asservita a queste. Tale modo di fare arte ha influenzato enormemente il mio sviluppo. Scegliere la tecnica adatta a infondere vita alle idee era certamente un concetto radicale per me a quel tempo e mi portò a sostituire l'universo pittorico con le immagini in movimento dei videotape. E poi ero molto interessato a comunicare con la mia generazione, che si era formata sostanzialmente tramite il mezzo televisivo. Quindi ho iniziato a dipingere set e fondali attraverso cui era possibile guardare nella telecamera e vedere l'immagine in tempo reale in televisione. Quindi in realtà la pittura non è mai scomparsa, ma certamente il video ha preso piede. Insomma per rispondere alla tua domanda, i miei primi nastri sono stati registrati nel 1976, quando avevo vent'anni.

SL: *Com'è avvenuto il passaggio dal video alle installazioni?*

TO: I miei primi videotape erano installati su sostegni fatti a mano e su "personaggi" che avevo realizzato per la produzione. Quindi in realtà l'installazione è sempre stata parte del processo. Si creava una specie di dinamica dentro/fuori che riverberava attraverso le rappresentazioni. I video e le installazioni sono diventati sempre più elaborati e dal 1981 al 1989 ho realizzato più o meno ogni anno un'installazione di grandi dimensioni. Le prime erano quasi sale di proiezione e le successive erano traboccanti di informazioni. Ero profondamente disincantato nei confronti della televisione come oggetto, tanto celebrato dalla precedente generazione

di artisti, quali Nan June Paik, Dara Burnbaum e altri che si trovarono nella posizione di convertire un utensile casalingo in arte, mentre io sentivo che la magia dell'utensile era ostacolata dalla scatola stessa. Quindi la maggior parte delle mie installazioni comprendeva la manipolazione dell'immagine-video per rimuoverla, a un passo dalla sua origine fisica, verso un altro spazio o dimensione. Ho usato di tutto, da sfere di cristallo incastonate nei muri, a specchi veri e specchi d'acqua. Le prime installazioni erano molto semplici e comprendevano fondali dipinti, quasi teatrali. Erano strutture temporanee, fatte di cartone e carta, legno e spago e in genere dovevano essere ricostruite ogni volta che aveva luogo l'esibizione. Si trattava di camere oscure. Sto parlando del 1981-1985. All'epoca di *Spillchamber*, nel 1989, fabbricavo la maggior parte delle mie installazioni con materiali durevoli, tipo resina, vetro e metallo.

Insomma anno dopo anno ho approfondito l'argomento, mentre sviluppavo e analizzavo le installazioni. Per esempio dal 1984, *Evol*, che è l'anagramma di "love", è stato una specie di studio elementare sui motivi dei vincoli umani, che poi ha condotto all'incarico da parte del Centre Pompidou di *Sphères d'Influence*, una grande installazione del 1985-86. Fanno parte integrante della mia ricerca registrazioni, quadri, performance, opere sonore e scritte che poi in qualche modo culminano in un'installazione.

SL: *La narrazione all'interno dei tuoi lavori rimane una componente fondamentale. In che modo gli scrittori e gli editori della tua famiglia hanno influito su questo aspetto?*

TO: Al lato paterno della mia famiglia appartengono moltissimi scrittori: i miei nonni hanno scritto un centinaio di libri ciascuno, dai polizieschi ai romanzi rosa, ai libri per bambini. Ma mio nonno era conosciuto soprattutto per il best-seller *The Greatest Story Ever Told*, una versione divulgativa della Bibbia, da cui fu tratto anche un film. Mio padre Fulton ha collaborato con il *Reader's Digest* per trent'anni, alla fine è diventato vicepresidente e dopo la pensione ha ripreso di nuovo a lavorare per *Guideposts Magazine*. Anzi ha anche fondato una propria rivista, *Angels on Earth*, che dopo appena due anni di vita ha già raggiunto una tiratura di venti milioni di copie. *Angels on Earth* racconta le storie vere degli angeli e del loro intervento sulla terra. Nella famiglia di mia madre Noel, invece, ci si dedicava alle arti visive. Sia mia nonna Loretta che mia madre erano pittrici dilettanti dotate di un certo talento e mi hanno incoraggiato molto; la prozia Zita ha insegnato arte per settant'anni ed è morta quando ne aveva 99. Quando ero un ragazzo mi ha insegnato a dipingere e mi ha influenzato molto, anche se non si considerava una vera artista.

SL: *Nei tuoi lavori l'uso che fai dell'elemento tempo è caratterizzante, cosa puoi dirci in proposito?*

TO: Molti anni fa ho letto da qualche parte che i frequentatori di musei trascorrono in media circa un secondo e mezzo di fronte ad ogni opera d'arte. Questo dato mi ha molto colpito; mi sono reso conto che spesso il pubblico si pone di

fronte all'opera d'arte come se si trattasse di una specie di test in cui bisogna trarre le risposte dall'opera stessa; una volta ottenutele, l'osservatore passa ad altro. Tale atteggiamento è emblematico del nostro sistema educativo e del triste stato in cui oggi versa la cultura negli Stati Uniti. La gente non ha fiducia nell'arte e crede che sia un'attività quasi d'élite, caratterizzata da una specie di atteggiamento di superiorità. Ma non ho intenzione di approfondire questo argomento adesso e vorrei ritornare all'elemento formale del tempo.

Credo che per infrangere la passività consentita all'osservatore da una scultura o da un dipinto, le installazioni e i videotape potrebbero costituire una sfida ai preconcetti degli osservatori verso l'arte stessa, poiché richiedono un certo lasso di tempo per essere recepiti. Alcune delle mie installazioni erano composte da cinque o sei elementi della durata di oltre un'ora ciascuno, che interagivano a caso l'uno con l'altro, quindi ogni volta che un osservatore entrava nella sala si trovava ad avere un'esperienza diversa. Tutto ciò ha cambiato anche il mio rapporto con una struttura contenutistica fissa, permettendo all'opera di rigenerarsi per il singolo osservatore. Mi piace l'idea che qualcuno, entrando in un ambiente in cui non è possibile recepire nulla nell'arco di pochi secondi o minuti, voglia "possedere" un'opera d'arte. In tal modo l'osservatore viene messo in una posizione diversa, deve prendere decisioni: dove collocarsi rispetto al prodotto artistico? Come interpretarlo? Quanto investire nel processo? Concepivo queste installazioni in termini di tempo cinematografico o letterario. Certo è rischioso, perché allora ti ritrovi in parte responsabile di quel tempo!

Le opere figurative che prevedono la proiezione di teste su bambole e pupazzi iniziò come esperimento sull'espansione temporale. Volevo eliminare una parte drammatica di una struttura narrativa; ad esempio in un film, il momento in cui un attore piange. In quel periodo volevo scomporre i generi cinematografici e pensavo sarebbe stato interessante assumere un attore che piangesse indefinitamente, così entrai in contatto con Tracy Leipold, che finì per recitare in molti miei lavori. Nel primo progetto che abbiamo realizzato, *Crying Doll*, Tracy piangeva per mezz'ora filata e il filmato è stato poi proiettato su una bambola di 20 centimetri. L'effetto complessivo è stato quello di un feto, o comunque di un essere umano di ridotte dimensioni, che soffriva tremendamente. Quest'opera venne concepita come un test sull'empatia dell'osservatore. Una caratteristica abbastanza sconcertante della tecnologia è la possibilità di simulare il moto perpetuo. Ciò che rende più efficace la bambola che piange è la sua abilità sovrumana di non smettere mai di farlo, il che a sua volta diventa orribile per l'osservatore, che alla fine deve andarsene. Tutto il test sull'empatia è proprio centrato sul momento in cui lo spettatore va via.

SL: *Nel cinema la capacità narrativa è frutto di immagini usate come parole, nei tuoi lavori invece le inquadrature rimangono ferme e il testo invece...*

TO: Nei film la grammatica cinematografica è usata come

una specie di cruda simulazione della percezione umana, ma io sono convinto che se si spengono le immagini e si ascolta soltanto il sonoro si comprenderà la storia altrettanto bene, e viceversa. In generale fare un film è un processo di impoverimento, del tutto ridondante. Direi che solo gli artisti comprendono davvero la relazione che esiste tra suono e immagine e il modo in cui questi due elementi si combinano tra loro a formare la conoscenza. Beh, forse anche qualcuno nel campo della pubblicità lo sa.

SL: *Nel 1965 Nam June Paik profetizzò in un suo saggio che: "il tubo catodico sostituirà la tela". Cosa ne pensi?*

TO: Anche John Baldassarri a un certo punto degli anni Settanta ha detto che il video è come una matita. Io ho affermato che il video è come l'acqua, è ovunque. E se oggi vai a vedere qualsiasi mostra d'arte puoi constatare che tutte queste affermazioni sono vere.

SL: *Riflettendo sulle tue opere puoi dirmi qualcosa di* Judy *e della MPD (Multiple Personality Disorder)?*

TO: La MPD è stata una metafora della persona postmoderna. Ho iniziato a studiarla approfonditamente intorno al 1992 e nel corso dei due anni successivi ho realizzato una serie di opere basate su questo argomento. La prima è stata *Judy*. Il titolo deriva da uno studio scientifico e dalla testimonianza di una paziente con quel nome. Se osserviamo le opere di Cindy Sherman, analizziamo la carriera di David Bowie, leggiamo su un quotidiano scandalistico storie di ricordi repressi e abusi rituali, oppure passiamo da un canale all'altro guardando la televisione, possiamo già renderci conto di come la MPD sia ovunque. *Judy* è un ritratto, nel tempo, di un personaggio frammentato. Ho deciso di usare un individuo come metafora di una tendenza culturale globale perché molto spesso ho la sensazione che questo consenta di essere più specifici e di collegare concetti generali a una situazione facilmente comprensibile. Dal punto di vista formale, l'opera era costituita da una linea che divideva la galleria e lungo questa erano collocate numerose entità Judy. L'osservatore era invitato a sedersi all'interno di quest'area e a parlare guardando un simulacro collocato all'esterno dello spazio espositivo, perpetuando in questo modo la catena delle molteplicità. Questo lavoro mi ha portato a ulteriori ricerche sulla MPD in rapporto alla struttura dei media. Mi ha sempre affascinato l'uso della tecnologia per espandere la psiche umana e il corpo. Quest'argomento mi interessa ancora oggi.

SL: *Cosa ne pensi del cammino intrapreso dall'arte contemporanea dopo Duchamp e dell'impasse a cui conduce la sterilizzazione duchampiana?*

TO: Beh, non credo che Duchamp sia responsabile di alcun insterilimento, ma di certo lo è stato dell'ulteriore intellettualizzazione del processo di creazione artistica. Duchamp era ovviamente un grande pensatore, ma se osserviamo tutta la sua produzione possiamo scoprire che la maggior parte delle sue opere possiede una qualità quasi viscerale, addirit-

tura umanistica. Credo che Duchamp abbia liberato il mondo dell'arte da un modello onanistico auto-referente. Duchamp ha salvato l'arte. Per inciso, un certo artista di cui non farò il nome mi ha detto una volta che Duchamp in realtà si manteneva facendo il mercante d'arte. Riflettici.

SL: *Talvolta i testi critici mettono in evidenza l'aspetto espressionistico del tuo lavoro, cosa ne pensi?*

TO: L'espressionismo non mi interessa molto e lo stesso si può dire dell'autobiografia o dell'auto-espressione. Nelle mie opere si può trovare un aspetto emotivo molto forte, ma generalmente derivano tutte da temi più vasti che cerco di analizzare. Provoco una sorta di relazione con l'osservatore, un dialogo che richiede a entrambi di esplorare una predisposizione a interpretare le cose in chiave espressionistica. Un tempo volevo realizzare un'opera d'arte che fosse come un puzzle gigante basato sul palinsesto televisivo statunitense. Credevo che guardando le storie e i notiziari, le *soap opera* e le commedie, i film e le pubblicità trasmesse dai cinque o sei canali che accompagnano gli americani per tutto il corso della giornata, si potesse decifrare una specie di codice e ottenere una sorta di libero accesso alla psiche degli americani. Negli Stati Uniti la televisione si basa su un sistema di indici di gradimento grazie al quale si continuano a trasmettere gli spettacoli di maggior successo mentre i programmi meno popolari vengono immediatamente cancellati; ne risulta un sistema di *feedback* "diretto" con il pubblico che produce un torrente continuo di informazioni, una sorta di espressionismo americano.

SL: *Da cosa deriva il lato inquietante delle tue opere?*

TO: È strano, molta gente me lo chiede. Suppongo sia parte della mia natura.

SL: *Quanto è importante il titolo nelle tue opere?*

TO: Tutte le parti di un'opera sono importanti.

SL: *Parliamo dei tuoi lavori su carta: che tipo di legame esiste con le installazioni?*

TO: Beh, ho appena pubblicato per la Kassel Kunstverein e la Octagon Press un libro che contiene i miei disegni degli ultimi vent'anni. In questo periodo ne ho realizzati un discreto numero, sia consciamente che inconsciamente. Nel mio lavoro è molto cambiato il concetto di segno e nel libro voglio sottolineare proprio quest'aspetto. Mostro come una linea passi da un mezzo all'altro, dalla matita alla pittura, al metallo, alla luce e di nuovo all'acquerello. Per me il disegno equivale a ciò che la scrittura rappresenta per un artista: spesso lo uso semplicemente per catturare le idee, come fosse un modo per ricordare. Nel corso degli anni, le immagini hanno avuto un grande significato per me, ma tra la fine degli anni Ottanta e l'inizio dei Novanta ho raggiunto una sorta di grado zero in termini di creazione di immagini. Ho completamente perso fiducia nel potere delle immagini e della composizione. Mi appariva come un'atti-

vità formale del tutto casuale che perpetuava una tradizione storica che consideravo ormai morta. In quel periodo, in realtà, realizzavo copie fotografiche molto semplici di acquerelli. Erano meditative e ripetitive; le ho spesso considerate come "degli Andy Warhol" alla rovescia. Lavoravo molto anche con le prime tecniche americane di decorazione, i logo delle società e perfino con i testi dipinti. Tuttavia, rimasi ben presto deluso e addirittura pensavo di non voler "creare" più nulla. Volevo costruire degli oggetti. Ho iniziato a curiosare per negozi alla ricerca di vestiti usati per creare i miei primi pupazzi che, naturalmente, non avevano la testa ed erano dotati di telecamere o piccoli televisori a circuito chiuso. In qualche modo volevo costruire una situazione anziché un'immagine. Quando riguardo queste opere trovo che esse siano piuttosto forti in termini di progettazione, ma all'epoca mi rifiutavo di considerarle sotto quest'aspetto. Pensavo più a situazioni di potere, alla tecnologia, a come essa amplifichi la forza e il desiderio degli uomini e la diffusione del corpo. Nello stesso tempo, il corpo era più di un simbolo mentre ogni volto era un'immagine e quindi sembrava appesantire troppo queste opere figurative, distruggendole, annientando le loro qualità antropomorfiche. Ogni volta che un pupazzo aveva l'immagine di un volto, la cosa non funzionava. Per questo, come ho già detto, tutti i primi pupazzi hanno tessuti uniformi al posto del viso. Poi, ovviamente, ho scoperto i piccoli proiettori LCD e ho iniziato a proiettare su quelli i volti. Nel periodo in cui realizzavo *Crying Dolls*, ero anche impegnato nella decostruzione della narrativa americana; il cinema attraverso il linguaggio. Ho creato una serie di pupazzi che descrivevano film, allo stesso modo in cui un amico racconterebbe a un altro la trama di un film e le scene che più gli sono piaciute. Trovavo affascinante il processo di *editing* del monolito cinematografico portato a compimento da un singolo individuo. Amo il modo in cui una persona è costretta a visualizzare le immagini attraverso questa narrazione ripetuta e l'ho voluta trasferire nei miei primi pupazzi. Essi spiegavano situazioni e immagini che l'osservatore avrebbe poi costruito nella propria mente. Per me, questo processo era di gran lunga più interessante di un film e consentiva di instaurare un più stretto rapporto di partecipazione con l'osservatore. È così, vedi, che dal grado zero sono arrivato a creare immagini in modo del tutto differente.

Più recentemente, sono tornato a dipingere e disegnare. Continuo a considerarlo un processo meditativo, ma adesso lo utilizzo come metodo d'indagine. Si tratta quasi di una cronologia delle mie ricerche. Li realizzo in più fasi, in maniera abbastanza intuitiva, ma di solito essi si sviluppano per argomenti. Adopero molte proiezioni e scopro immagini interpretate e manipolate, e utilizzo anche una serie di assistenti che mi aiutano a costruire stili e tecniche diverse per ogni opera. Analizzo, interpreto la storia della comunicazione audiovisiva: esperimenti televisivi degli anni Venti e Trenta collegati alla trasmissione, la prima tecnologia computerizzata e satellitare, l'immagine dei detriti tecnologici. Questo è il genere di materiale di base che è risultato nella mostra allestita alla Galleria 1000eventi. In realtà, era la pri-

ma volta in dieci anni che presentavo opere di grafica con video installazioni. Ero sorpreso dall'interazione tra i due mezzi. Secondo me, tra i due si instaurava un dialogo poetico che dava alla galleria un aspetto molto familiare e non so spiegarmene il perché.

SL: *A poco a poco, le tue installazioni con i pupazzi vengono sostituite da proiezioni di parti del corpo, come nel caso di* Digital *e di* Molecule, Méliès. *Inoltre, il volto intero viene ridotto a una bocca* (Bull's Balls) *o a un occhio. Come è avvenuto questo passaggio?*

TO: In realtà il cambiamento non è stato così lento. Ho sempre lavorato anche ad altri *tropoi* oltre le bambole e i pupazzi. Sono convinto che la gente sia attratta in particolare dai volti, che trasmettono molte informazioni su di noi. Al confronto, il resto del corpo è irrilevante. Ne consegue l'evoluzione del primo piano e la testa parlante in televisione. Il fatto non ha eguali in termini di qualità psicologiche riflesse, la gente ricorderà o recepirà un volto in movimento più facilmente di qualsiasi altra cosa.
Ho sempre nutrito un grande interesse per la trasmigrazione del viso e per ciò che rappresenta, fin dai miei primi nastri degli anni Settanta. La personificazione dei testicoli del toro, presentata in questa mostra, è un'estensione logica di quella ricerca. Ma di nuovo, si torna alla tecnologia. Frankenstein, in questo caso, o forse dovrei dire la clonazione: l'opera, secondo me, si colloca tra le due. *Molecule, Méliès* è ispirata al grande regista francese e alle sue costruzioni fantasiose. L'opera ha in sé parte della magia dei primi film, elementi collegati tra di loro a formare qualcosa di più grande. Secondo me, Méliès è stato il simbolo di una prima ricerca interiore della tecnologia, in un'epoca in cui gli altri cineasti si limitavano a realizzare documentari di viaggi, girati in esterno. Méliès ha dato inizio al grande e bizzarro viaggio interiore. Quando oggi guardiamo verso l'interno, non scopriamo altro che zero e uno, *on* e *off*, bianco o nero: tutto è digitale. *Digital* è stata di certo ispirata dalla natura stessa di quella tecnologia. Dal punto di vista formale, ho tradotto pixel digitali in blocchi tridimensionali, come accade in televisione quando si vuole rendere irriconoscibile un criminale o un sospettato e si digitalizza il volto di quella persona per proteggere il suo anonimato. In questo caso ho anche utilizzato la manipolazione digitale dei nastri per giocare con il linguaggio e l'aspetto fisico del volto applicando una sorta di processo di *scratching* digitale che viene poi proiettato sui blocchi. Chuck Close era molto all'avanguardia per i suoi tempi.

Video is like Water

Simona Lodi, Tony Oursler

Simona Lodi*: How did you begin using video to produce art for the first time?*

Tony Oursler: In 1976 I went to the California Institute for the Arts; I was a painter at the time, and had some strange idea about evolving the history of art through my craft. For instance, starting out as a photo realist and perfecting that technique before I could move on to abstraction. Sort of along the lines of Mondrian's progression. So this was the kind of thinking that I was involved with at the time. I was really into the Surrealists. Back in my hometown, Nyack, New York, I had met Robert Breer, the famous animator and artist, whose daughter, Sophie, I was quite close to. He showed me some of his films as well as those of Pat O'Neil, and I was overwhelmed with the possibility of moving images becoming art. So anyway, I found myself in California, studying with some of the first generation conceptual artists who had the idea that form followed content. In other words, their philosophy was that artists focused on ideas over craft, which was subservient. This process of art-making was extremely influential on my development. Choosing the proper technique to breathe life into ideas was certainly a radical idea for me at the time and led me to replacing the pictorial field with the moving image of videotape. Also, I was really interested in speaking to my own generation, which I felt was primarily formed by the medium of television. So I started painting sets and backdrops through the while looking through the camera and seeing the image in real time on television. So the painting never really left, but the video certainly took over. So to answer your question, my first tapes were made in 1976, when I was twenty.

SL*: How did it happen, the passing from video to installation?*

TO: My very first videotapes were installed with handmade props and "characters" which I made for the production. So, in fact, installation was always part of the process. There was a kind of inside/outside dynamic which reverberated through the presentations. The videotapes and the installations became more and more elaborate and from 1981–1989 I did roughly one large installation a year. The first installations were almost like screening rooms and the later installations were packed with information. I was very disenchanted with the television as an object which had been celebrated by the previous generation of artists, such as Nan June Paik, Dara Burnbaum, and others who found them-

selves in the position of converting a household appliance into art, whereas I felt like the magic of the appliance was hindered by the box itself. So most of my installations involved manipulating the video image to remove it one step from its physical origin into another space or dimension. I used everything from crystal spheres embedded in the walls to mirrors and pools of water. The first installations were really simple and involved painted almost theatrical backdrops. They were very temporal, made of cardboard and paper, wood and string and generally had to be reconstituted every time they were exhibited. These were dark rooms. I'm talking about 1981-1985. By *Spillchamber*, in 1989, I was fabricating quite a bit of my installations out of more concrete material such as resin, glass and metal.

So year by year I moved through subject matter as I developed and researched my installations. For example, *Evol*, which is "love" spelled backwards, from 1984, was a kind of elemental study of the motifs of human bonding, which then led to the commission by the Centre Pompidou of *Sphères d'Influence*, a large installation in 1985-86. As part of my research process, I would spin off tapes, paintings, performances, soundworks and writings, and then somehow this would all culminate in an installation.

SL: *The narrative is a fundamental component of your work, how did your family of writers and editors influence you?*

TO: My father's side of the family was full of writers; my grandmother and grandfather wrote roughly a hundred books each, ranging from detective stories to romance novels, children's books and so forth. But my grandfather was most well-known for his best-selling book, *The Greatest Story Ever Told*, which was a popularization of the Bible and became a film. My father Fulton worked for *Reader's Digest* for thirty years, eventually became vice-president, and recently came out of retirement to work for *Guideposts Magazine* and started his own magazine entitled *Angels on Earth* which is just over two years old and has reached over one million circulation. This magazine is devoted to real-life stories of angels and their interventions on Earth. My mother Noel's side of the family were the visual artists. Both my grandmother Loretta and my mother were quite talented Sunday painters and were very encouraging; my great-aunt Zita taught art for seventy years and just passed away in her 99th year. She taught me painting when I was young, and was a great inspiration, although she never considered herself an artist.

SL: *The time element is very important to you. What can you say about this?*

TO: I read somewhere many years ago that the average museum-goer spends about one second and a half in front of each artwork and this statistic hit me very hard. I realized that often the public has a confrontational attitude towards artwork as though it's some sort of test and they're trying to figure out how to get the answer from the artwork; and once received, the viewer moves on. This is symptomatic

of our educational system and the sad state of culture in the United States at the moment. People don't trust art, and believe that it's an "insider activity," which is always talking down to them. But I'm not going to get too much into this problem at the moment, and stick to the more formal element of time.

I felt that to break the passive quality that a painting or sculpture might allow the viewer, installations and video-tapes, which allow a certain amount of time to be absorbed, would challenge the viewers preconception of art itself. Some of my installations had five or six elements of more than an hour each, randomly interacting with one another, so that whenever the viewer entered the room, there was a different experience to be had. This, of course, also changed my relationship to a set structure of content and allowed the work to recreate itself for the individual viewer. I like the idea of someone expecting to "get" an artwork entering an environment where they can't possibly absorb anything within a few seconds or minutes – thus the viewer is put into a different position; they must make a decision of where they stand in relation to the artwork, how they want to read it, how much do they want to invest in the process? I was thinking in terms of these installations as having cinematic or literary time. Of course this is risky because you are then in part responsible for that time!

The figurative works involving projected heads on dolls and dummies began as an experiment in time expansion. I was interested in removing one dramatic part of a narrative structure. For example, the moment in a movie where an actor weeps – at the time I was deconstructing cinematic genres and I thought it would be interesting to hire a performer to weep indefinitely, which is how I became involved with Tracy Leipold, who ended up performing in many works. But the first project we did, *Crying Doll*, featured Tracy weeping for a half an hour straight. This was then projected onto an eight inch doll. The overall effect was an almost fetal, or diminished human who was suffering tremendously. This work was intended to be an empathy test for the viewer. One characteristic of technology, which is quiet disconcerting, is that of the perpetual action. What makes the crying doll most effective is its superhuman ability to never stop weeping, which in turn becomes horrifying for the viewer, who eventually must turn away. It is that moment of turning away which the empathy test is all about.

SL: *In movies, the images are used to tell the story. Instead, in your works, the shots don't move but there is some "action." Can you explain this?*

TO: In movies, the filmic grammar is used as a sort of crude simulation of human perception, although I think you would find that if you turned the picture off and listened to the sound, you would know the story just as well, or vice-versa. Generally, movie-making is an impoverished medium, wholly redundant. I would say that it's only artists who truly understand the relationship between sound and pictures and how they combine to form cognition. Well, O.K., maybe some people in advertising as well.

SL: *In 1965 Nam June Paik, in one of his texts, predicted: "Cathode tube will replace the canvas." What do you think of this?*

TO: Also, John Baldessari said that video is like a pencil somewhere in the seventies. I said that video is like water; it's everywhere, and if you go to any art exhibition today, you can see that all these statements are true.

SL: *Can you talk about* Judy *and Multiple Personality Disorder?*

TO: MPD was a metaphor for a postmodern persona and thus I began to study its particulars around 1992 and made a series of works based on this interest over the next couple of years. But first was *Judy*. The title came from an actual medical study and testimony of a patient by the same name. If you look at the works of Cindy Sherman or the career of David Bowie, or pick up a tabloid newspaper featuring stories of repressed memory and ritual abuse, or pick up the remote control while watching TV some evening, and switch from station to station, you begin to understand the ubiquity of MPD. *Judy* is a portrait, over time, of one character who fractures into many. I decided to use an individual as a metaphor for an overall cultural propensity, as I often do feel that it allows one to be more specific, to tie overarching concepts to a situation everyone can understand. Formally, the work was organized in a line which dissected the gallery and various Judy entities were spread along that line. The viewer was invited to sit in the piece and speak and look through a simulacrum placed outside of the exhibition space, thus continuing the chain of multiplicity. This work led me to further explorations of MPD in relation to media structures, which has always fascinated me; the uses of technology to expand the human psyche and body. This continues to interest me today.

SL: *What has happened to contemporary art after Duchamp? Do you think that Duchamp sterilized art production and has driven it to a dead end?*

TO: Well, to answer your second question, no, I don't think that Duchamp has led to sterilization but certainly a further intellectualization of the art making process. He was obviously a great thinker, but if you look at the overall production of his life, I think you'll find a quite visceral quality to many of the works, even humanist. I think Duchamp freed the art world from a wanking self-reflective model. Duchamp saved art. Just as an aside, a certain artist who will remain unknown once told me that Duchamp in fact supported himself as a dealer of art. Think about that.

SL: *Sometimes critics have commented on the expressionistic aspect of your work. Do you agree with them?*

TO: No, expressionism is not of great interest to me, nor is autobiography or self-expression. There may be a very emotive aspect to my works, but they generally come from larger issues that I'm trying to explore, a kind of relationship with the viewer, a dialogue which asks us both to

explore a predisposition to read things in an expressionistic manner. I used to imagine a giant puzzle of an art work which I would someday make based on the schedule of the television channels in the U.S. That somehow if you looked at the five or six channels programming throughout the day, the selection of narratives and news, soap operas and comedies, movies and advertisements that guide Americans through the day, that you could crack some sort of code – gain some sort of entry into the American psyche. Television in the U.S. is based on a rating system whereby the most popular shows remain on the air and unpopular programs vanish immediately, so you have a "direct" feedback system on a mean with the public, which results in an endless stream of information, a kind of American Expressionism.

SL: *Where does the dark side of your work come from?*

TO: It's funny, a lot of people ask me that. I guess it's just in my nature.

SL: *How important are the titles of your works?*

TO: All parts of the work are important.

SL: *Can you explain the relationship between the drawings on paper and the video installations?*

TO: Well, I recently just published a book of twenty years of my drawings through the Kassel Kunstverein and Octagon Press. Because drawing is something that I've done quite a bit over the years, consciously and unconsciously. The idea of mark-making has changed quite a bit in my work, and I try to present that in the book, to show a line going from medium to medium, going from pencil to paint, to metal to light and back to watercolors. To me, drawing is very close to writing for an artist – I often use it simply to capture ideas as a way of remembering. Images have meant many things to me through the years, but somewhere in the late eighties early nineties I came to a kind of ground zero in terms of image-making. I lost faith completely in the power of the image, in the power of composition. It just seemed like so much random formal activity and carrying on the historical baggage of a tradition which seemed quite dead to me. At that point I was doing very simple renderings of objects in watercolors-cameras, in fact. They were meditative and repetitive. I often thought of them as inverted Andy Warhols. Also, I was working a lot with early American decorative techniques and corporate logos, and even painted texts. But somehow, I became so completely disenchanted, I didn't even want to "make" anything anymore. I wanted to set things up. I started going around to thrift stores and buying used clothes to produce my first dummies. These, of course, had no heads and were wired with surveillance equipment or miniature closed circuit televisions. Somehow I wanted to make a situation instead of an image. When I look back on these works, they are quite strong in terms of design, but I refused to think of them in that way at the time. I was thinking more

of power situations, technology, and how it expanded human power and desire, and the dissemination of the body. At the same time, the body was more of a symbol while any sort of visage was an image, and thus seemed to anchor any of these figurative works too much, destroying them, deadening their anthropomorphic qualities. Whenever a dummy had an image of a face, it didn't work, so as I said all the first dummies had plain patterned materials where there should be a face. Then, of course, I discovered that small LCD projectors and began to project the faces. Around the time that I was making the *Crying Dolls*, I was also deconstructing the American narrative; the cinema through language. I produced a series of dummies which described movies, much in the same way that a friend would explain the plot of a movie and their favorite parts to one another. This process of editing the industrial monolith of cinema by the individual was fascinating. I really love the way that one is forced to imagine the images through this process of retelling, so I transposed that onto my first projected dummies. They would explain situations and images which the viewer would then construct in their mind. For me, this was much more exciting than any movie could be; and a much more participatory relationship with the viewer. So you see, I went from ground zero to creating images in a completely different manner.

More recently, I returned to painting and drawing in a big way. I still look at it as a meditative process, but now I use it as a research process. It's almost a chronology of my research. I develop them in a number of stages, quite intuitively, but they generally flow in terms of subject matter. I use a lot of projections and found images which are interpreted and manipulated as well as a number of assistants to build up a series of different styles and techniques from work to work. I'm looking back at, interpreting, the history of audio-visual communications: television lab experiments of the twenties and thirties related to broadcast television, early computer and satellite technologies, the image of technological detritus. This is the kind of source material which ended up in the exhibition at Galleria 1000eventi. In fact, this was the first time that I exhibited graphics with video installations in about ten years. I was surprised by the interaction between the two. For me, there was a lyrical dialogue between the two, it gave the gallery a very domestic look, and I'm not sure exactly why. Also, there was a lyrical dialogue between the two.

SL: *Little by little, the figurative installations are replaced by other surfaces, in the case of* Digital *and* Molecule, Méliès; *also, the full face is reduced to a mouth (*Bull's Balls*) or an eye. Can you explain this evolution?*

TO: It's not really little by little. I have always been working with other tropes besides the dolls and dummies. I have a theory about this which is that people are most attracted to the face. It carries the most information about us for many reasons. The rest of the body is inconsequential in comparison. Thus, the evolution of the close-up and the talking head on television. The fact is unmatched in psy-

chological reflective qualities, so I think that people will always remember or are receptive to a moving face above almost anything else.

The transmigration of the face and what it signs has always been of interest to me, even since my first tapes in the seventies. The personification of the bull's testicles in this exhibition is a logical extension of that exploration. But again, it comes back to technology. Frankenstein, in this case, or should I say cloning for me the work is located somewhere in between the two. *Molecule, Méliès* was inspired by the great French filmmaker and his fanciful constructions. It has a bit of the early movie magic to it, elements connected to one another which could form something much greater than themselves. For me, Méliès was a symbol of a first inward exploration of technology whereas other filmmakers of his day were shooting outdoor documentary travelogue footage. He began the great whimsical journey inward. Today when we look inward, we find that everything is zeros and ones, either on or off, black or white; it's all digital. *Digital* was certainly inspired by the very nature of that technology. Formally, I translated digital pixels into three-dimensional blocks, much as they do on television when trying to disguise a criminal or suspect. They digitalize that person's face to protect their anonymity. Here also I use digital tape manipulation to play with language and the physical rendering of the face by using a kind of digital scratching process, which is then projected onto the blocks. Chuck Close was far ahead of his time.

Opere
Works

Blue/White State, 1997

Proiettore, videotape, VCR, sedia, figura grande, treppiedi

Projector, videotape, VCR, chair, big shape, tripod

91,4x182,8x91,4 cm

BLUE BLUE BLUE
WHY IS MY BRAIN DIFFERENT
I CAN'T BREATHE
OH...THAT'S THE WAY IT IS
IT'S SOOO WHITE PURE WHITE. I CAN'T SEE
ANYTHING.
CUT IT DOWN TO SIZE, SMALLER, LITTLE THING
HOW MUCH IS FACT? FICTION? WHO CARES
LET'S HEAR ANOTHER VIEW NOW...
PHYSCOGENIC? BIOLOGICAL? BOTH
SOME TRAUMA IN THE PAST
I'M JUST WIRED THAT WAY. THE SKY
WHAT WERE YOU GOING TO TELL ME
I DON'T WANT ANY OF YOUR CHARITY
HIGHER AND HIGHER AND HIGHER AND HIGHER ALL
THE WAY
TOO MUCH BLUE OH MY MY NO WHITE
GET BACK ON YOUR HIGH HORSE OH SIDE ON INTO
THE BLUE
WHAT WENT WRONG? -WHAT WAS IT? BLACK OUT
WHITE-OUT (SNIFF)
I ACTED OF MY OWN FREE WILL
SCATTER, ISOLATED, INCOMPLETE DATA, SKETCHY,
FUZZ.
(COUGH) DUST DOWN HERE, DUSTY
COMMUNICATION (COUGH)
A LITTLE MORE BLUE A LITTLE MORE WHITE THAT'S
A LAME EXCUSE
RADAR, SPY, IRRATIONAL, SURPRISE ME
YOU MAY HAVE A REAL PSYCHOLOGICAL MISTRUST
BLANK BLANK BLANK BLUE BLUE BLUE
THAT WOULD SEND A TERRIBLE MESSAGE TO
SOCIETY
THERE'S NOTHING THERE
I'M WAY OVER MY HEAD...
EAT MY FLESH, DRINK MY BLOOD
BLIND, BLIND, BLIND SNOW BLIND
IT DOESN'T MATTER ANYWAY, CONTACT? NO
FORGET IT
THE SKY SEEMS TO GO NO FOREVER
LET'S GET IT OVER WITH HAPPY HOUR
PURE AS DRIVEN SNOW
DON'T TURN BLUE PLEASE DON'T
MY SOUL IS IS, SO...

T.O.

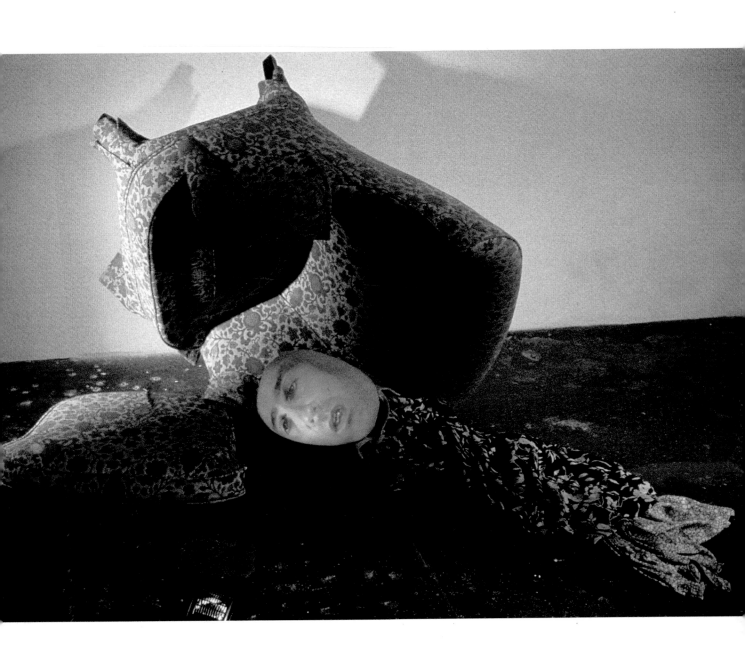

Digital, 1997

Proiettore, VCR, videotape, 23 blocchi di legno,
ogni blocco 15,2x15,2x22,8 cm

Projector, VCR, videotape, 23 blocks of wood,
each block 15,2x15,2x22,8 cm

dimensione totale/total dimension 19,3x137,1x91,44 cm

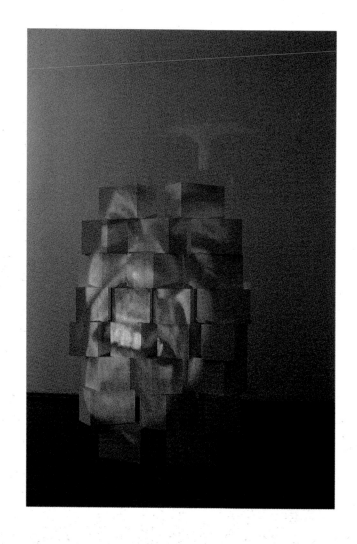

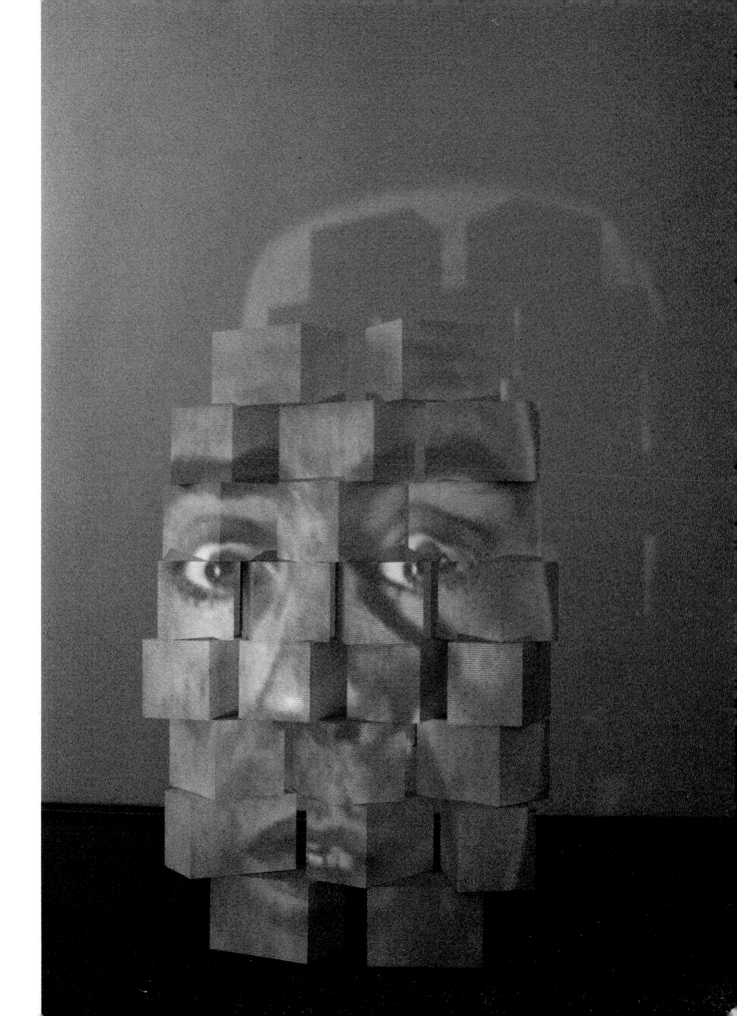

Out of it, 1996

Proiettore, VCR, videotape, acrilico su sfera di fibra di vetro

Projector, VCR, videotape, acrylic on glass fibre sphere

45,7 cm ø

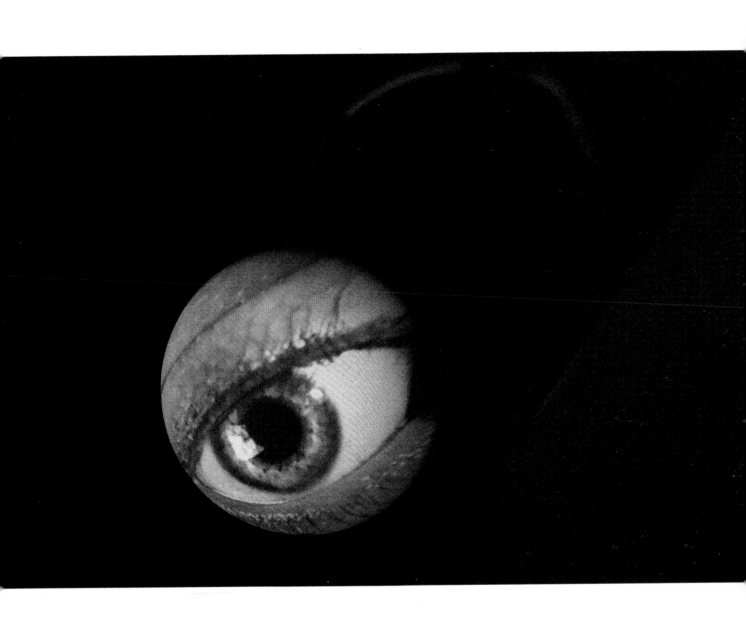

Bull's Balls, 1997

Proiettore, VCR, videotape, piccolo treppiedi, barattolo di vetro di
7,6 cm, base in metallo, testicoli di toro, conservante

Projector, VCR, videotape, little tripod, glass pot (7,6 cm), metal
basement, bull testicles, preservative

114,3x22,8x22,8 cm

HA HA HA HA HA HA TAUT, FERM, STIFF, TIGHT, HA
HA

OUCH! DELETE, EXPLETIVE, OFFENSIVE. WHO'S
GUNNA TAKE CARE OF ME?

I'M GUNNA BUST YOU OUT HAAAA
OOOOOOOHHHHHH

WHAAAAAA BOOOOO LOCK OUT CHANG SMACK HA
HA AHHA HA AH

GET OUT OF MY FACE SUCKER SUCK SMACK ICKY
BOOO BOO BLOOD BLOOD

DIMPLE BIRDY FALLING DOWN BLOOD MAN
HURTER 5 67 ESCAPE WACKS

HA HA HA I WANT TO TELL YOU A SECRET
SSSSSHHHHHHHHH QUIET

HUFFY AND PUFF ER HOOFER OH BABY THE HURTS!
HURTS! HURTS! HURTS!

STOP IT, HARDER HARDER HARDER HARDER
HARDER HARDER HA AHHA AH HA

HARDER DYNAMITE TWANG RIVIT POP PLEASURE
BUTTON NOW IT FLOWS

GIDDY GIDDY GIDDY GIDDY GIDDY GIDDY UP SILLY
COWBOY SUNSET EAST BURNING SPACESHIP CRASH
BOOM HA AHHA AH HA HA AH

DUMMY COMPUTER NO FREEKEN MEMORY HAAAA
DOWERNER BLAAAAAAA

DO YOU KNOW HOW STRONG I REALLY AM? DO
YOU? TAKE A GOOD LOOK.

PLEASE DON'T UNDERESTIMATE ME, FOCUS ON THE
DETAILS

HA HA AH ONCE YOU HAVE TASTED THE FRUIT OF
THE GODS ITS DIFFICULT TO WALK AMONG MEYER
MORTALS OR SOMETHING LIKE THAT

78 GO TO HEAVEN. BOOM! THE PRIVATE PARTS ARE
GONE! BOOM!

WHAT ARE YA PACKEN THERE SOLDIER? WHO'S THE
SHOOTER? WHERES THE
FIRE? HA AHHA AH HA HA AH

GO ON GIVE IT YER BEST SHOT HAAA HAAA IS THAT
ALL YOU GOT HA HA AH

SHE'LL BE COMM'N ROUND THE MOUNTIAN WHEN
SHE COMES

CHICKEN! SHAKEN IN YER BOOTS, BABY BOOOOO
HHOOOOOO WHAAAAA

DIM WIT DOOO DOOO SNAPPER GOOD BOY
FIGHTER HARD AS NAILSHA HA AH

PUSSY

T.O.

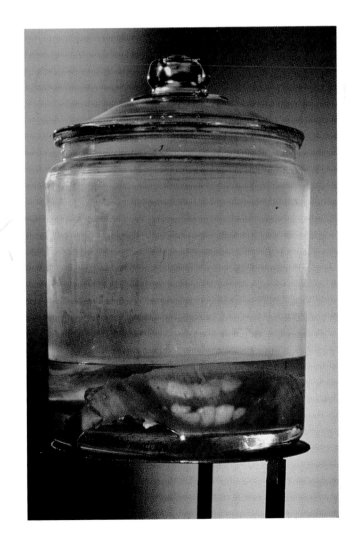

Molecule, Méliès, 1997

Proiettore, VCR, videotape, polistirolo espanso, pittura

Projector, VCR, videotape, foam plystyrene, painting

45,7x45,7x15,2 cm

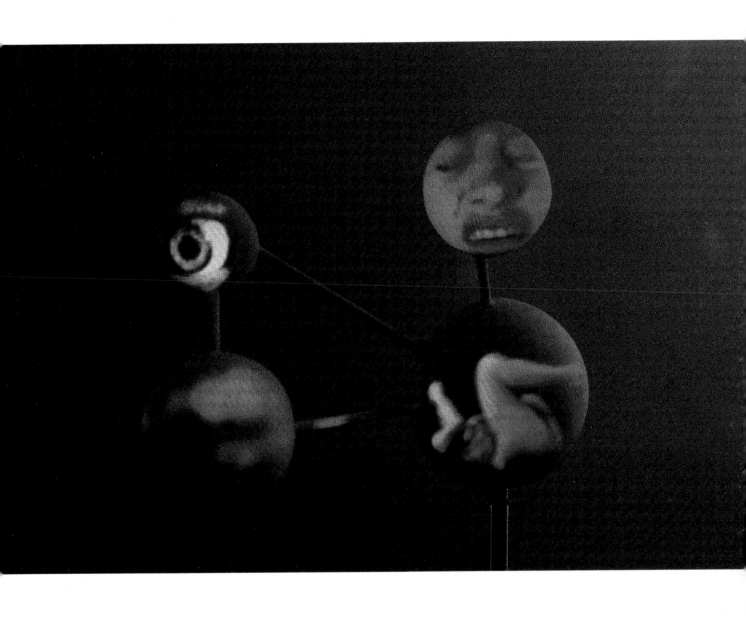

IN/OUT OUT/IN, 1997

2 proiettori, 2 VCR, videotape, polistirolo espanso, pittura

2 projectors, 2 VCR, videotape, foam polystyrene, painting

ogni testa/each head 35,5x33x33 cm

THEORETICAL BACK DROP
NOTHING TO HIDE, BOOM , KISS ON THE LIPS
NO MESSAGE, MY CROWN, MONEY, UP
LOOK FOR SOME RAIN SHOWERS, WHAT DO I CARE
NO TOP
YOU ARE A BORE, BANNED, SNAP SPIN, DOWN
I WILL NOT FIGHT, NOW, STAY TUNED, BLUR, WEAK
DEATH, LIVE, YOUR MISSING OUT, TIME CHARM
LET ME IN, LET ME GO, CHILDREN, MUTILATION
I KNOW YOUR THERE, MISSION CONTROL,
STRNAGE
ANTI TOP
SICK, SICK, SICK VICTORY, NO SLEEP, STRONG
TRANSMISSION OF FORCE
WHAT A PARTY, TROPICAL, A HELL OF A LOT OF FUN
I DIDN'T DO ANYTHING WRONG ,TOP
IT'S O.K., THEIR PAST, NEXT, SENSORY
MAKE IT GO AWAY, I'LL BE THINKING OF YOU,
BOTTOM
YOU KNOW I LIKE YOU, WEAK
SELF EMPOWERMENT, SUCKY, SUCKER, SUCK OFF,
STRONG
TWIST AND SHOUT, ALL NEW EPISODE, TERMINAL
DISSITIGRADE, I'M NOT CLEAR, ICE AGE
MISCONDUCT, IDOL, ICE CREAM, CRUEL
I'LL BE LONELY THIS TIME, PLAGUE
HOW DOES THIS WORK? WEAK
HEY HEY HEY HEY DON'T JUDGE ME
IT'S SO DEEP, DOOM, DARK. PHOTON
BEAUTY, BLISS, JOY, WARM WARMER WARMEST
YOU HAVE HAD YOUR TIME, TWILIGHT
LIES, LIVE, LOST, LOWER
I DIDN'T WANT TO STOP
CONSTITUENTS OF MATTER

T.O.

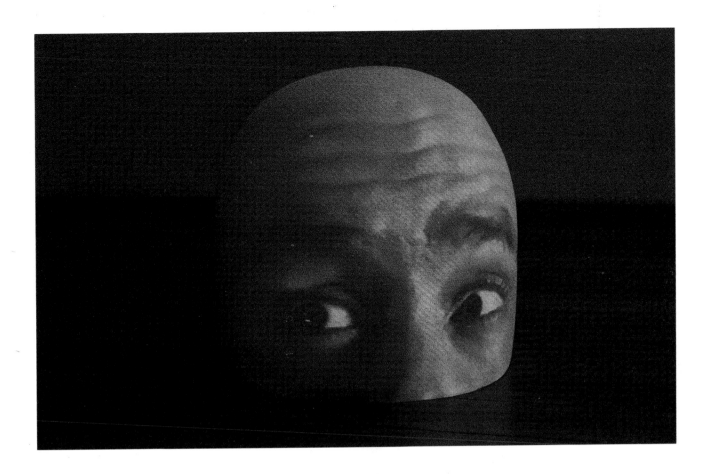

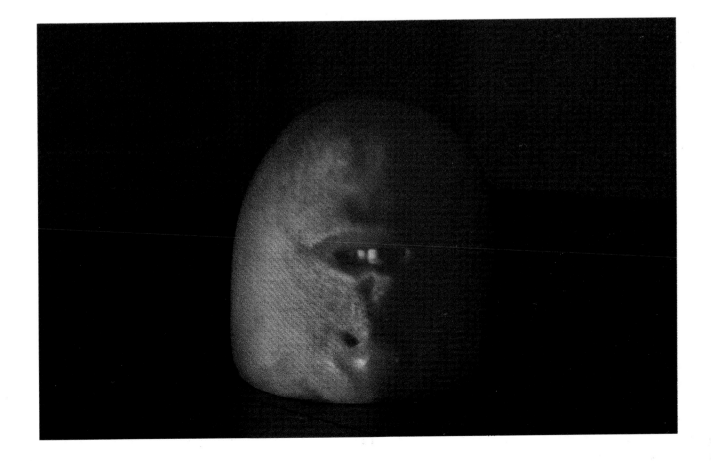

Damage, 1998

Proiettore, VCR, videotape, acrilico su sfera di fibra di vetro

Projector, VCR, videotape, acrylic on glass fibre sphere

20x35x20 cm

WHAT HAPPENED?
UNEXPECTED EVENTS, RANDOM, DESTRUCTIVE
THE IMPACT, THE STRUCTURE, THE DAMAGE
REBROADCAST IT ALL
I WANT TO ASK YOU (4X)
GET A NEW JOB
THEY WERE BEGGING SAYING NO! NO! NO!
CHARACTURE? WHERE ARE YOU?
NEXT (3X) YOU LOOK LIKE YOU COULD USE SOME
HELP.
WILL YOU STOP TALKING FOR A MOMENT ... QUITE
LET IT LIVE
WHO, ME, YOU, THEM, US? YOU DIDN'T SEE THIS. NO,
YOUR REMOTE CONTROL, YOU, ARE.
CAN'T YOU SEE I'M THINKING
PEOPLE ORDINARY PEOPLE
OH MY GOODNESS IT'S BROKEN, I DIDN'T HAVE ANY
CHOICE
FIRING INTO THE HOLE, WHAT NEXT?
WHAT YOU SEE IS WHAT YOU GET, DAMAGED GOODS.
COME TOGETHER EVERYONE PLEASE
LOOK AT THAT MESS, I'M NOT SURE WHY I DID WHAT
I DID
THE LAST STARRING ROLE, GOING DOWN
TRANSLUCENT
BE CAREFUL WHAT YOU WISH, YOU MAY GET IT
THE LEGACY I CAN'T REMEMBER ANY OF IT.
JUST LOOK AT THE BRIGHT SIDE OF THINGS.
WHO CONTROLS WHAT, DON'T LET ME GO INSANE
EXPOSURE, SATURATED, THINK! STAY TUNED
INCRIMINATING EVIDENCE IN THE FORM OF A
DREAM,
WHAT DO YOU THINK? LOOK AT IT ... IT'S A START
THE FIRST SCENE OF THE FIRST EPISODE
THE CLOSER I GET THE FARTHER IT IS.
I HEAR VOICES, I'M BETRAYED. I'M MARTYRED.
WHAT ARE YOU GOING TO DO CALL THE POLICE
HISTORY HAS DONE ITS WORK
WHAT HAPPENED TO ME? I APPRECIATE YOUR TIME
DO IT, FAST, LIVE THROUGH IT.
WATCH OUT. LUCKY YOU.
KEEP LOOKING
TAKE IT FROM THE TOP

T.O.

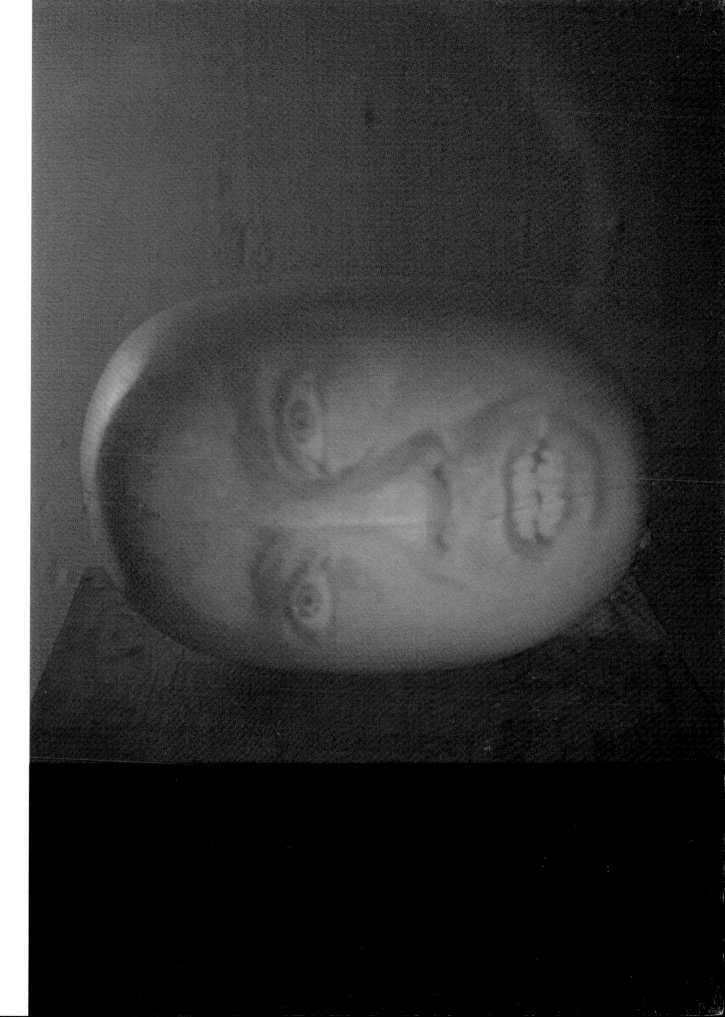

Opere su carta
Works on paper

Pole, 1997

Tecnica mista su carta

Mixed media on paper

55,8x76,2 cm

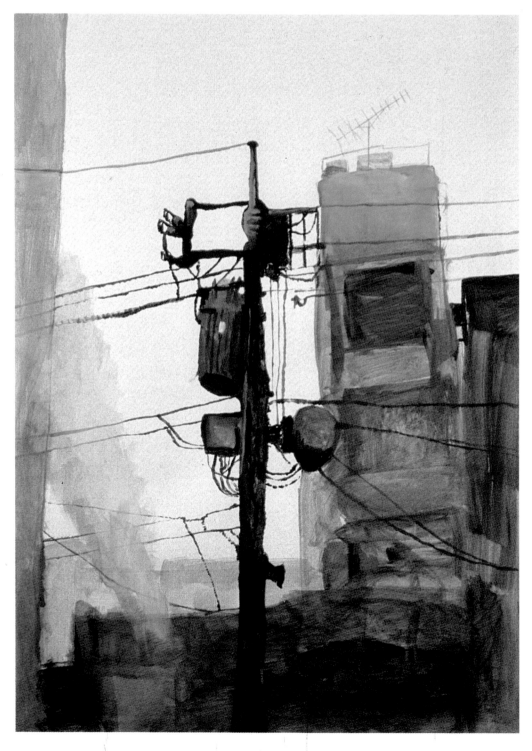

Dish, 1997

Tecnica mista su carta

Mixed media on paper

55,8x76,2 cm

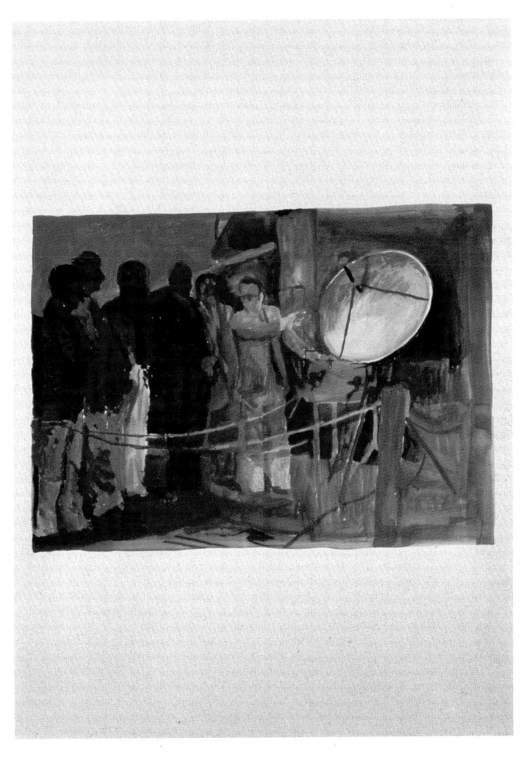

Madison-San Antonio-Daton, 1997

Tecnica mista su carta

Mixed media on paper

55,8x76,2 cm

Conference Room, 1997

Tecnica mista su carta

Mixed media on paper

55,8x76,2 cm

First TV, 1997

Effects of Trasmission Impairments, 1998

Tecnica mista su carta

Mixed media on paper

55,8x76,2 cm

Tecnica mista su carta,

Mixed media on paper

55,8x76,2 cm

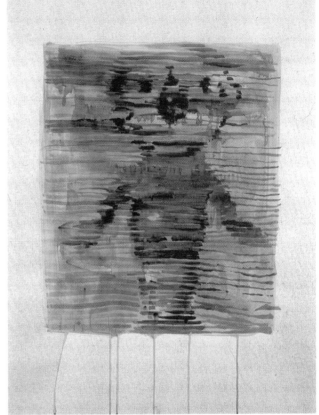

Tony Oursler è nato nel 1957 a
New York dove vive
e lavora. Ha frequentato
il California Institute for
the Arts, 1979, B.F.A.

He was born in 1957 in New
York where he lives and works.
Attended California Institute for
the Arts, 1979, B.F.A.

Esposizioni
Exhibitions

Personali
One-person exhibitions

1981

University Art Museum, University of California, Berkeley

"Video Viewpoints", The Museum of Modern Art, New York

The School of the Art Institute of Chicago, Chicago

1982

The Walker Art Center, Minneapolis

Boston Film/Video Foundation, Boston

"A Scene", P.S. 1, New York

"Complete Works", The Kitchen, New York

Soho TV M/T Channel 10, New York

1983

La Mamelle, San Francisco

"My Sets", Media Study, Buffalo, USA

"Son of Oil", A Space, Toronto

"Panic House", Los Angeles Contemporary Exhibitions, Los Angeles

1984

Anthology Film Archives, New York

"L-7, L-5", The Kitchen, New York

David Mo Gallery, New York

1985

Kijkhuis, Den Haag, Holland

Kunst Delft, Delft, Holland

ELAC, Espace Lyonnais d'Art Contemporain, Lyon

Schule fur Gestaltung, Basel

The American Center, Paris

1986

"Sphères d'Influence", Centre Georges Pompidou, Paris (cat. della mostra/ex. cat.)

New Langton Arts, San Francisco

Nova Scotia College of Art and Design, Nova Scotia, Canada

Boston Film/Video Foundation, Boston

1987

The Kitchen, New York

1988

"Tony Oursler's Works", Le Lieu, Quebec City

"Constellation: Intermission", Diane Brown Gallery, New York

Western Front, Vancouver

Los Angeles Center for Photographic Studies/EZTV, Los Angeles

1989

Folkwang Museum, Essen, Deutschland (cat. della mostra/ex. cat.)

Collective for Living Cinema, New York

Museum fur Gegenwartskunst, Basel

Bobo Gallery, San Francisco

1990

Hallwalls, Buffalo, New York

Diane Brown Gallery, New York

The Kitchen, New York

"On Our Own", Segue Gallery, New York

1991

Diane Brown Gallery, New York

"Dummies, Hex Signs, Watercolours", The Living Room, San Francisco

The Pacific Film Archives, San Francisco

The Cinemathèque, San Francisco

1992

"F/X Plotter, 2 Way Hex", Het Kijkhuis, Den Haag

The Space, Boston

The Knitting Factory, New York

1993

"White Trash and Phobic", Centre d'Art Contemporain, Genève; Kunstwerke, Berlin (cat. della mostra/ex. cat.)

Andrea Rosen Gallery, New York

The Living Room, San Francisco

"Dummies, Dolls, and Poison Candy", Ikon Gallery, Birmingham; Bluecoat Gallery, Liverpool (cat. della mostra/ex. cat.)

1994

Lisson Gallery, London

Jean Bernier Gallery, Athìna

Linda Cathcart Gallery, Santa Monica, California

"Dummies, Flowers, Alters, Clouds, and Organs", Metro Pictures, New York

"Tony Oursler-Recent Video Works", The Contemporary Museum, Honolulu, Hawaii

1995

"rum", Malmö, Sweden

"System for Dramatic Feedback", Portikus, Frankfurt; Les Musées de la Ville de Strasbourg, Strasbourg; Centre d'Art Contemporain, Genève; Stedelijk Van Abbemuseum,

Holland; (itinerante/traveling, cat. della mostra/ex. cat.)

"Tony Oursler: Video Installations, Objects, Watercolors", Musée des Arts Modernes et Contemporains, Strasbourg, France; Galerie Ghislaine Hussenot, Paris Wiener Secession, Wien

1996
Lisson Gallery, London

Metro Pictures, New York

Museum of Contemporary Art, San Diego, California (cat. della mostra/ex. cat.)

"Tony Oursler-My Drawings 1976-1996", Kasseler Kunstverein, Kassel (24 novembre/november - 5 gennaio/january, cat. della mostra/ex. cat.)

Jean Bernier Gallery, Athina

1997
"Judy", Institute of Contemporary Art, Philadelphia

Margo Leavin Gallery, Los Angeles

Aspen Art Museum, Aspen, Colorado

Paule Anglim, San Francisco

Galerie Biedermann, München

capcmusée, Musée d'art contemporain, Bordeaux (31 ottobre/october - 11 gennaio/january 1998, cat. della mostra/ex. cat.)

Gallery Koyanagi, Tokyo

"Der menschliche Faktor - Das individuum im Spiegel der zeitgenosslschen Kunst", Hypo Bank S.A., Luxembourg (5 febbraio/ february - 16 gennaio/january 1998), Kunsthandel Achenbach, Düsseldorf (5-28 febbraio/ february)

"The Video Room", White Columns, New York

1998
1000eventi, Milano

Collettive selezionate
Selected group exhibitions

1983
"X Catholic" (performance in collaborazione con/in collaboration with Mike Kelley), Beyond Baroque, Los Angeles

1984
"The Luminous Image", Stedelijk Museum, Amsterdam (cat. della mostra/ex. cat.)

1987
"L'époque, la mode, la morale, la passion", Centre Georges Pompidou, Paris

"Aspects of Media: Video", Department of Video/Art, Advisory Service of the Museum of Modern Art for Johnson & Johnson, New York

"Japan 1987 Television and Video Festival", Spiral, Tokyo

"Documenta 8", Kassel

"Schema", Baskerville + Watson Gallery, New York

1988
"The BiNational: American Art of the Late 80s, German Art of the Late 80s", Institute of Contemporary Art, Museum of Fine Arts, Boston; Stadtische Kunsthalle, Düsseldorf; Kunsthalle Bremen, Bremen; Wurttembergischer Kunstverein, Stuttgart (cat. della mostra/ex. cat.)

"Film Video Arts, 17 Years",

The Museum of Modern Art, New York

"World Wide Video Festival", Den Haag

"Twilight, Festival Belluard 88 Bolwerk", Freiburg

"2nd Videonale", Bonn

"New York Dagen", Kunstichting, Rotterdam

"Videografia", Barcelona

"Varitish", Corea

"New York Musikk", Oslo

"Festival International du Nouveau Cinéma et de la Video", Montreal

"Replacement", LACE, Los Angeles

"Interfermental 7", Hallwalls, Buffalo, New York

"Serious Fun Festival", installation for Alice Tully Hall, Lincoln Center, New York

1989
"1989 Biennial Exhibition", Whitney Museum of American Art, New York

"Video Sculpture 1963-1989", Kolnischer Kunstverein, Köln

"XII Salso Film & TV Festival", Salsomaggiore, Italia

"Relatives" (video performance in collaborazione con/in collaboration with Constance DeJong), the Kitchen, New York; Rockland Center for the Arts, West Nyack, New York; Seattle Arts Museum, Washington; Mikery Theatre, Amsterdam; ECG-TV Studios, Frankfurt

"Drawings, Objects, Videotapes", Delta Gallery, Düsseldorf Museum, Düsseldorf

"Masterpieces", Stadtgarten, Köln

"Nepotism", Hallwalls, Buffalo, New York

"Video and Language", The Museum of Modern Art, New York

"Sanity is Madness", The Artists Foundation Gallery, Boston

"World Wide Video Festival", Den Haag

1990
"The Technological Muse", Katonah Museum of Art, Katonah, New York

"Tendance Multiples, Video des Années 80", Centre Georges Pompidou, Paris

"Video/Objects/Installations/ Photography", Howard Yezerski Gallery, Boston

"Video Transforms Television: Communicating Unease", New Langton Arts, San Francisco

1991
"The New York Times Festival", Museum van Hedendaagse Kunst, Gent, Belgique

"Triune", Bluecoat Gallery, Video Positive Festival, Liverpool

1992
"Documenta 9", Kassel

"Station Project" (in collaborazione con/in collaboration with James Casebere), Kortrijk Railway Station, Belgique

1993
"Love Again", Kunstraum Elbschloss, Hamburg

"3rd International Biennale in Nagoya-Artec '93", Nagoya City Art Museum, Nagoya, Japan

"Private", Gallery F-15, Oslo

1994

"The Laugh of #12", Fort Asperen, Amsterdam

Galleria Galliani, Genova

"The Figure", The Lobby Gallery, Deutsche Bank, New York

"Tony Oursler and John Kessler", Salzburg Kunstverein, Salzburg (cat. della mostra/ex. cat.)

Metro Pictures, New York

"A Sculpture Show", Marian Goodman Gallery, New York

"Two-person show with Jim Shaw", Laura Carpenter Fine Art, Santa Fe, New Mexico (in collaborazione con/in collaboration with Jim Shaw)

"Home Video Redefined: Media, Sculpture and Domesticity", Center of Contemporary Art, Miami

"Light", ARTprop, New York

"Medienbiennale 94, Minima Media", Leipzig, Deutschland

"Beeld", Museum van Hedendaagsekunst, Gent, Belgique

"Oh Boy, It's a Girl: Feminismen in der Kunst", Kunstverein, München (cat. della mostra/ex. cat.)

1995

"ARS 95 Helsinki", Museum of Contemporary Art, Helsinki, Finland (cat. della mostra/ex. cat.)

"The Message is the Medium: Issues of Representation in Modern Technologies", Castle Gallery, College of New Rochelle, New York

"Zeichen & Wunder", Kunsthaus Zurich; Centro Galego de Arte Contemporanea (cat. della mostra/ex. cat.)

Galleria 1000eventi, Milano, gennaio/january 1998

"Entre'Acte 1", Stedelijk Van Abbe museum, Amsterdam

"Festishism", Brighton Museum and Art Gallery, Brighton

"Fantastic Prayers" (in collaborazione con /in collaboration with Constance DeJong e/and Stephen Vitiello), world wide web site project and performance, Dia Center for the Arts Rushmore Festival, New York

"Le Printemps de Cahors", Cahors, France

"Inside Out: Psychological Self-Portraiture", The Aldrich Museum of Contemporary Art, Ridgefield, Connecticut (cat. della mostra/ex. cat.)

"Trust", Tramway, Glasgow

Mendelson Gallery, Pittsburgh

"Video Spaces: Eight Installations", The Museum of Modern Art, New York (cat. della mostra/ex. cat.)

Metro Pictures, New York

"Man & Machine: Technology Art", Dong-Ah Gallery, Seoul, Corea

"Configura 2 - Dialog Der Kulturen - Erfurt 1995", Erfurt, Deutschland (cat. della mostra/ex. cat.)

"L'Effet Cinéma", Musée d'Art Contemporain de Montréal

"1995 Carnegie International", The Carnegie Museum of Art, Pittsburgh

"Biennale d'Art Contemporain de Lyon", Maison de Lyon, Lyon

"Passions Privée", Musée d'Art Moderne de la Ville de Paris, Paris

"Playtime: Artists and Toys", testi di/essays by Eugenie Tsai, Angela Kramer Murphy,

Jennifer L. Gauthier, Cynthia Roznoy, Whitney Museum of American Art at Champion, Stamford, Connecticut (cat. della mostra/ex. cat.)

1996

"Sampler 2", David Zwirner, New York

"Empty Dress", The Rubelle & Norman Schafler Gallery, Pratt Institute, Brooklyn

"Altered and Irrational", Whitney Museum of American Art, New York

"Sex & Crime: On Human Relationships", Sprengel Museum, Hannover (cat. della mostra/ex. cat.)

"Kingdom of Flora", Shoshana Wayne Gallery, Santa Monica, California

"Human Technology", Revolution, Ferndale, Minnesota

"Young Americans: New American Art in the Saatchi Collection", Saatchi Gallery, London (cat. della mostra/ex. cat.)

Metro Pictures, New York

Lisson Gallery, London

"Tomorrow", Rockland Center for the Arts, West Nyack, New York

The Cincinnati Art Musem, Ohio

"New York 'Unplugged II'", Gallery Cotthem, Knokke-Zoute, Belgique

"Phantasmagoria", Museum of Contemporary Art, Sydney (cat. della mostra/ex. cat.)

Metro Pictures, New York

"Radical Images", Österreichische Triennale zur Fotografie, Neue Galerie am Landesmuseum Joanneum, Camera Austria in the Kunsthalle Szombathely, Graz, Österreich (cat. della mostra/ex. cat.)

"Scream & Scream Again, Film in Art", Museum of Modern Art, Oxford, USA

10th Biennale of Sydney, Sydney (cat. della mostra/ex. cat.)

"Matthew Barney, Tony Oursler, Jeff Wall", Sammlung Goetz, München (cat. della mostra/ex. cat.)

"Being & Time: The Emergence of Video Projection", The Albright Knox Art Gallery, Buffalo, New York

"New Persona/New Universe", Biennale di Firenze, Firenze

Philadelphia Museum of Art, Philadelphia (performance con/with Constance De Jong)

"The Red Gate", Whitney Museum of American Art, New York; Museum van Hedendaagse Kunst, Gent, Belgique (cat. della mostra/ex. cat.)

"The Scream", The Nordic Arts Centre, Helsingfors, Finland (cat. della mostra/ex. cat.)

"Face Value: American Portraits", itinerante/traveling venues from The Parrish Art Museum, Southampton, New York; Wexner Center for the Arts, Columbus, Ohio; Tampa Art Museum, Tampa, Florida (cat. della mostra/ex. cat.)

"Intermission", Basilico Fine Arts, New York, luglio/july

"ID", Van Abbemuseum, Eindhoven, Holland

1997

"Anatomy of Space/Time", Kobe Fashion Museum, Kobe, Japan (marzo/march)

Centre Georges Pompidou, Paris (maggio/may)

The Digital Video Wall, Rockefeller Center, New York (21 febbraio/february -30 aprile/april)

"Scream and Scream Again. Film in Art", The Irish Museum of Modern Art, Dublin (14 febbraio/february - 16 aprile/april)

"The Whitney Biennial", Whitney Museum of Contemporary Art, New York (cat. della mostra/ex. cat.)

The Performing Garage, New York (performance con/with Constance DeJong e/and Stephen Vitiello)

"Gothic", The Institute of Contemporary Art, Boston (cat. della mostra/ex. cat.)

"M.A. Thesis Exhibition", Center For Curatorial Studies, Bard College, New York

"Skulptur Projekte", Münster, Deutschland (22 giugno/june-28 settembre/September, cat. della mostra/ex. cat.)

"The Poetics Project, 1977-1997" (in collaborazione con/in collaboration with Mike Kelley), Documenta X, Kassel

"Angel: Angel", Kunsthalle Wien, Wien (11 giugno/june - 7 settembre/september); Galerie Rudolfinum Prag, Österreich (24 ottobre/ october-11 gennaio/january 1998, cat. della mostra/ex. cat.)

"Identité", Institute of Contemporary Art, Boston (26 giugno/ june-31 ottobre/october)

"Being and Time: The Emergence of Video Projection", Contemporary Arts Museum, Texas (16 agosto/august-5 ottobre/october); Site Santa Fe, Santa Fe, New Mexico (1 novembre/november-25 gennaio/january, cat. della mostra/ex. cat.)

Barbara Krakow Gallery, Boston

"The Body", The Art Gallery of New South Wales, Sydney (12 settembre/september-16 novembre/november, cat. della mostra/ex. cat.)

"Installations/Projects", P.S. 1, New York

"World Wide Video Festival", Stedelijk Museum, Amsterdam (12 settembre/september-5 ottobre/october)

Patrick Painter, Santa Monica, California (in collaborazione con/in collaboration with Mike Kelley)

"Zones of Disturbance", steirischer herbst 97, Graz, Österreich (28 settembre/september-31 ottobre/october, cat. della mostra/ex. cat.)

"Der Menschliche Faktor-Das Individuum im Spiegel zeitgenossischen Kunst", Hypobank International S.A., Luxembourg (14 novembre/november - 16 gennaio/january, cat. della mostra/ex. cat.)

The Eli Broad Family Foundation, Santa Monica, California

"The Poetics Project" (in collaborazione con/ in collaboration with Mike Kelley), Watari-um, the Watari Museum of Contemporary Art, Tokyo (23 novembre/november - 29 marzo/march 1998, cat. della mostra/ex. cat.)

1998

"Presumed Innocence", Anderson Gallery, Virginia Commonwealth University, Richmond, Virginia (17 gennaio/january-1 marzo/march)

"The Secret Life of Clothes", The Nishinippon, Fukuoka, Japan (22 gennaio/january-10 maggio/may, cat. della mostra/ex. cat.)

Video/Videos

1976

"Joe, Joe's Transexual Brother and Joe's Woman", 25 mins., b/w

1977

"The Life of Phillis", 55 mins., b/w

1976-97

"Poetic's Reenactment Rock Videos" (featuring Robert Appleton)

"Pole Dance" (in collaborazione con/in collaboration with Mike Kelley & Anita Pace)

1978

"Life", 10 mins., b/w

1979

"Good Things + Bad Things", 10 mins., b/w

"Diamond Head", 25 mins., b/w

"Selected Shorts", 20 mins., col.

"The Rosery Finger of Dawn", 10 mins., col.

"The Loner", 32 mins., col.

1981

"Grand Mal", 23 mins., col.

1982

"Son of Oil", 18 mins., col.

1983

"Spinout", 17 mins., col.

"Theme Song From Si Fi", 5 mins., col.

"Rome Hilton", 2 mins., col.

"My Class", 12 mins., col., col.

1984

"Evol", 30 mins., col.

1985

"Sphères d'Influence", 45 mins., col.

1986

"Diamond the 8 Lights: Sphères d'Influence", 55 mins., col.

1987

"Sucker", 5 mins.

1988

"ONOUROWN" (in collaborazione con/in collaboration with Joe Gibbons), 47 mins., col.

"Joy Ride TM" (in collaborazione con/in collaboration with Constance DeJong), 15 mins., col.

1990

"Tunic (for Karen)", 6 mins., col.

1991

"Kepone", 10 mins., col.

1992

"Toxic Detox", (in collaborazione con/in collaboration with Joe Gibbons), 27 mins., col.

1992-93

"Triptych/Model Release" (in collaborazione con/in collaboration with Constance DeJong), 3 mins., col.

"Paranoid Schizoid Position", (in collaborazione con/in collaboration with Kim Gordon), 2 mins., col.

"Test" (in collaborazione con/in collaboration with Karen Finlay), 5 mins., col.

1993-97

"Air"

1996

"Little Wonder" (in collaborazione con/in collaboration with David Bowie)

1997

"Selected Documentation of Installations"

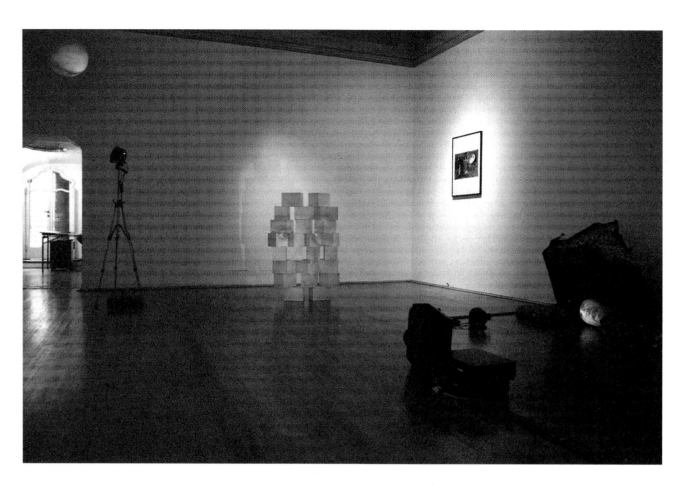

Galleria 1000eventi, Milano, 1998

Bibliografia selezionata
Selected Bibliography

1982
J. Hoberman, "The Weak Bullet; The Loner; Grand Mal", *The Village Voice*, 23 marzo/march

1983
Robert Atkins, "Chicago", *Artforum*, aprile/april

1984
Arlene Zeichnèr, "Critique of Pure Reason", *The Village Voice*, 3 aprile/april

The Luminous Image, testo di/essay by Constance DeJong, Stedelijk Museum (cat. della mostra/ex. cat.)

1985
Kim Gordon, "American Prayers", *Artforum*, pp. 73-77

Ann-Sargent Wooster, "Tony Oursler at MO David", *Art in America*, dicembre/december

1986
Sphères d'Influence, Centre Georges Pompidou (cat. della mostra/ex. cat.)

Dorothée Lalanne, "Tony Oursler: Dernier Soir", *Cinéma*, febbraio/february

1987
Jean Paul Fargier, "Installation à Beaubourg", *Le Journal Cahiers du Cinema*, febbraio/february, p. 380

Dorothée Lalanne, "Tony Oursler: Dernier Soir", *Cinéma*, febbraio/february, p. 10

1988
John Berlinsky, "The Light Fantastic", Metro, ottobre/october

Jurgen Hohmeyer, "Die Fernbedienung der Kunstgeschichte", *Der Spiegel*, p. 52

Elspeth Sage, "The Joy of Collaboration: An Interview with Constance DeJong and Tony Oursler", *Vancouver Guide*, p. 4

1989
C. Carr, "Constance Dejong and Tony Oursler: Relatives, The Kitchen", *Artforum*, maggio/may, p. 27

Charles Hagen, "Video Art: The Fabulous Chameleon", *Artnews*, estate/Summer, p. 88

Regina Lange, "Media Power, Video-arbeiten von Tony Oursler", *Apex-Heft*, p. 70

Margaret Tiberio, "Method to this Media: An Interview with Tony Oursler", *Visions*, a publication for the media arts by the Boston Film/Video Foundation, estate/Summer, p. 3

Michael Blowen, "A Stunning Mix of Images and Words at ICA", *The Boston Globe*

1990
Jaako Lintinen, "Uudella Mediataiteella Taitaa Olla Halussaan 90-luvun Avaimet" (To Break into the New Media Arts is to Possess the Key to the 1990s), *Taide*, p. 2

Andy Grundberg, "Review/ Photography, Tony Oursler, Diane Brown Gallery", *The New York Times*, 8 giugno/june

Amy Taubin, "Choices", *Village Voice*, 20 giugno/june

Doug Hall and Sally Jo Fifer eds., *Illuminating Video: An Essential Guide to Video Art*, New York, Aperture Foundation

David Joselit, "Mind Over Matter: Tony Oursler and Ericka Beckman Master the Politics of Art", *The Boston Phoenix*, settembre/september 7

Joshua Decter, "Tony Oursler, Diane Brown Gallery", *Arts Magazine*, ottobre/october, p. 65

John Miller, "Tony Oursler, Diane Brown Gallery", *Artforum*, ottobre/october, p. 29

1991
Tony Labat, "Tony Oursler", *Shift*, p. 5

Heather Mackey, "Something Fishy Going On", *After Dark*, febbraio/february

1992
Peter Iden, "Trotz großer Fulle sehr, sehr wenig", Frankfurter Rundschau, 13 giugno/june

Alan G. Artner, "Matter Over Mind", *The Chicago Tribune*, 28 giugno/june

Regina Cornwell, "Great Videos, Shame About the Show", *Art Monthly*, settembre/september

Y. Ramirez, "Diane Brown Gallery", *Art in America*, maggio/may

1993
Tony Oursler: White Trash and Phobic, an introduction by Elizabeth Janus, Centre d'Art Contemporain, Genève and Kunst-werke, Berlin (cat. della mostra/ex. cat.)

Stephen Sarrazin, "Tony Oursler en de nieuwe gedaante van de videokunst", *Metropolis M*, p. 6

Chris Meigh-Andrews, "Tony Oursler", *Art Monthly*, novembre/november

Amy Taubin, "The Big Sleep", *The Village Voice*, 3 agosto/august

Gertrud Sandquist, "Privat", *Parkett*

1994

Waldemar Januszczak, "Heart of the Matter", *The New York Times*, 27 febbraio/february

Sarah Kent, "Dummy Copy", *Time Out*, 16 febbraio/ february

Cherie Henderson, "Household items star in art show", *The Miami Herald*, 6 febbraio/february

Helen L. Kohen, "Home video never looked like this", *The Miami Herald*, 27 febbraio/ february

Geraldine Norman, "Saatchi Swoops for Video Pieces", *The London Times*, febbraio/ february

Richard Dorment, "Portraits for the Age of Anxiety", *Daily Telegraph, London* (febbraio-marzo/february-march)

Kim Levin, "Trans-Europe Express", *The Village Voice*, 27 settembre/september, p. 94

Carlo McCormick, "True Terror", *Paper*, novembre/november, p. 31

Elizabeth Janus, "Sue Williams, Renée Green, Tony Oursler", *Furor (Voltaire)*, settembre/september, n. 26

Renate Puvogel, "Tony Oursler-System for Dramatic Feedback", *Kunstforum*, novembre/november, pp. 403-404

Rudolf Schmitz, "Frankfurt: Tony Oursler im Portikus", *Kunstbulletin*, ottobre/october, p. 39

Let Geerling, "De lach van de gehangene", *Metropolis M*, no.4, pp. 34-39

Din Pieters, "Het geheim achter het lachen", *NRC Handelsblad*, 6 ottobre/october

Marijn Van Derjagt, "Reis van onder-naar bovenlichaam", *De Groene Amsterdammer*, 15 giugno/june

Martin Pesch, "Tony Ourslers Videoskulpturen in Frankfurt: Mehr als Medien-Feedback", *Frankfurt Neue Presse (Die Tageszeitung)*, 30 settembre/ september

G.N., "Der Betrachter wird selber zum Objekt", *Frankfurter Neue Presse*, 27 agosto/august

G.N., "Der Mensch von heute schreit sein Angst heraus", *Frankfurter Neue Presse*

Dorothée Baer-Bogenschutz, "Beobachter der Beobachter", *Frankfurter Rundschau*, 22 settembre/september

Peter Schjeldahl, "Get Out of Here", *The Village Voice*, 29 novembre/november, p. 97

Roberta Smith, "Tony Oursler", *The New York Times*, 25 novembre/november, p. C24

Jorg Heiser, "Den Plot ernst nehmet—Tony Oursler's Installation 'System for Dramatic Feedback'", *Texte Zur Kunst*, pp. 191-194

Andreas Spiegel, "Jon Kessler/Tony Oursler", *Arti*, novembre-dicembre/ november-december, vol. 22, pp. 208-211

1995

Martha Schwendener, "Tony Oursler: Dummies, Flowers, Alters, Clouds, and Organs", *Art Papers*, gennaio-febbraio/ january-february, p. 59

Michael Duncan, "Tony Oursler at Metro Pictures", *Art in America*, gennaio/ january, p. 105

Joshua Decter, "Tony Oursler, Metro Pictures", *Artforum*, febbraio/february, p. 89

Gregory Volk, "Tony Oursler, Metro Pictures", *Artnews*, febbraio/february, p. 127

Robert G. Edelman, "Tony Oursler", *Art Press*, febbraio/february, No. 199, pp. VI-VII

Friedemann Malsch and Elizabeth Janus, eds., *Tony Oursler: Dummies, Clouds, Organs, Flowers, Watercolors, Videotapes, Alters, Performances and Dolls*, Portikus, Frankfurt; Les Musées de la Ville du Strasbourg, Strasbourg, Centre d'Art Contemporain, Genève; Stedelijk Van Abbe Museum, Eindhoven

Isabelle Bratschi, "Tony Oursler Parvient à Faire Parler d'Etranges Poupées", *Le Courrier*, Genève, 3 febbraio/ february

Monique-Priscille Druey, "L'Americain Oursler Hurle à Genève", *Tribune des Arts*, marzo/march, p. 15

Tony Oursler, "Why I Like Flowers", *Paletten*, marzo/march, pp. 30-33

J.P.F., "Tony Oursler", *Le Monde*, 19-20 marzo/march

Face Value: American Portraits, testi di/essays by Donna De Salvo et al., The Parrish Art Museum, South Hampton, New York (cat. della mostra/ ex. cat.)

Zeichen & Wunder, testo di/text by Bice Curiger et al., Kunsthaus Zurich; Centro Galego de Arte Contemporanea (cat. della mostra/ex. cat.)

ARS 95 Helsinki, testi di/essays by Maaretta Jaukkori and Tuula Arkio et al., Museum of Contemporary Art, Helsinki

Carol Vogel, "Inside Art", *The New York Times*, 7 aprile/april

Inside Out: Psychological Self-Portraiture, testo di/essay by Douglas F. Maxwell, The Aldrich Museum of Contemporary Art, (cat. della mostra/ex. cat.)

John C. Welchman, "Tony Oursler: Angels of the Techno-Grotesque", *Art + Text*, maggio/may, n. 51, p. 227

Video Spaces: Eight Installations, testo di/text by Barbara London, The Museum of Modern Art, New York (cat. della mostra/ex. cat.)

Charles Hagen, "Back in Fashion, Video Installations", *The New York Times*, 11 luglio/july, pp. C-13, C-15

Grace Glueck, "Turn On, Tune In and Drop By: Video Art's Come a Long Way", *The New York Observer*, 24 luglio/ july, p. 20

John Russell, "Portraits That Beckon To the Cross-Examiner", *The New York Times*, 11 agosto/august, p. C30

David Colman, "The Art Screen Scene", *Artforum*, settembre/september, pp. 9-10

Arthur C. Danto, "Art: TV and Video", *The Nation*, 11 settembre/september, pp. 248-253

Eleanor Heartney, "Video in Sity", *Art in America*, ottobre/october, pp. 94-99

Jim Lewis, "Doll Parts", *Spin*, novembre/november, p. 28

Matthew Ritchie, "Video Spaces: Eight Installations, MOMA", *Zingmagazine*, New York, autunno/Autumn

Gabi Czöppan, "Künstler des jahres", *Focus*, Deutschland, ottobre/october, pp. 146-150

L'Effet Cinéma, testo di/text by Olivier Asselin, Musée d'art Contemporain de Montréal (cat. della mostra/ex. cat.)

Elizabeth Licata, "Living With Art", Artnews, dicembre/december, pp. 87-90

Tony Oursler: Obra Reciente, testo di/essay by Octavio Zaya, Galeria Soledad Lorenzo, Madrid (cat. della mostra/ex. cat.)

Playtime: Artists and Toys, testi di/essays by Eugenie Tsai, Angela Kramer Murphy, Jennifer L. Gauthier, Cynthia Roznoy, Whitney Museum of American Art at Champion, Stamford, Connecticut (cat. della mostra/ex. cat.)

1996

Roberta Smith, "A Neo-Surrealist Show With a Revisionist Agenda", The New York Times, 12 gennaio/january, p. C23

William Zimmer, "No Simple Innocence, Childhood Now Invoked Has More in Tow", The New York Times, 21 gennaio/january, pp. CN 16

Matthew Ritchie, "Tony Oursler: Technology As An Instinct Amplifier", Flash Art, gennaio-febbraio/january-february, pp. 76-79

Young Americans: New American Art in the Saatchi Collection, testi di/essays by Jeffrey Deitch e nove artisti/and nine participating artists, Saatchi Gallery, London (cat. della mostra/ex. cat.)

Susan Kandel, "'Kingdom of Flora' Blooms Again", Los Angeles Times, 22 febbraio/february, pp. F3, F12

Lisa Berke, "Short Bytes:

Kingdom of Flora", Los Angeles Jewish Times, 15 marzo/march

Martin Herbert, "Project Yourself Onto This" (intervista/interview), Dazed & Confused, aprile/april, pp. 102-104

Sarah Ward, "Tony Oursler", Art in Context (web site), 17 maggio/may

Howard Halle, "The Vision Thing", Time Out New York, 1-8 maggio/may, p. 22

Leslie Camhi, "A Sharpies's Crisis", The Village Voice, 7 maggio/may, p. 79-80

"Tony Oursler", The New Yorker, 20 maggio/may, pp. 16-17

Martin Maloney, "Young Americans: Parts I & II", Flash Art, maggio-giugno/may-june, pp. 108-109

Ronald Ehmke, ed., con/with Elizabeth Licata, Consider the Alternatives: 20 Years of Contemporary Art at Hallwalls, Buffalo, NY: Hallwalls,Inc.

Phantasmagoria, testo di/essay by Warren Niesluchowski, Museum of Contemporary Art, Sydney (cat. della mostra/ex. cat.)

Sex & Crime: On Human Relationships, testo di/essays by Fritz Haarmann and Ulrich Krempel, Sprengel Museum, Hannover (cat. della mostra/ex. cat.)

Sarah Ward, "Tony Oursler at Metro Pictures" (recensione/review), Art In Context (art review magazine on Internet)

Holland Cotter, "Optic Nerve", Art in America, giugno/june, pp. 92-95

Yanase Kaoru, "Tony Oursler", BT, vol. 48, n. 726,

giugno/june, pp. 53-59

Reiko Tomii, "New York", Bijutsu Shinbun, n. 767, 1 giugno/june

David Batchelor, "Tony Oursler - Lisson Gallery", Artforum, estate/Summer, p. 118

Radical Images, 2nd Austrian Triennial on Photography 1996, Neue Galerie am Landesmuseum Joanneum, Graz and Camera Austria in the Kunsthalle, Szombathely (cat. della mostra/ex. cat.)

Leah Ollman, "Art That Talks Back: The Shrink Is In", Los Angeles Times (Calendar Section), 30 giugno/june, pp. 55-56

Caryn James, "Art Flickers From Video Screens", The New York Times, 26 luglio/july, pp. C1, C4

Tony Oursler, una conversazione con/a written conversation with Christiane Meyer-Stoll e/and Jim Lewis, Museum of Contemporary Art, San Diego, California (cat. della mostra/ex. cat.)

Cecilia Anderson, "Tony Oursler" (recensione/review), Katalog, Denmark, autunno/Autumn, p. 50

Tracey Hummer, "Tony Oursler" (recensione/review), Sculpture, settembre/september, pp. 63-64

Frances Richard, "Like Water", Parkett, n. 47, pp. 46-49 (inglese/English), pp. 50-53 (tedesco/German)

Lynne Cooke, "Tony Oursler Alters", Parkett, n. 47, pp.38-41 (inglese/English), pp. 42-45 (tedesco/German)

ID - An International Survey on the Notion of Identity in

Contemporary Art, testi di/essays by Jan Debbaut, Jaap Guldemond, Oliver Sacks, Mats Stjernstedt, Gregor Muir, Jean Fisher, Stephanie Moisdon, Mark Kremer, Lynne Cooke, Michelle Nicol, Adam Chodzko, Stedelijk Van Abbemuseum, Eindhoven, 1996, pp. 71-77 (cat. della mostra/ex. cat.)

Tony Oursler, Tracy Leipold conversazione con/in conversation with Louise Neri "Oursler/ Leipold/Neri: A Conversation in the Green Room", Parkett, n. 47, pp. 21-27 (inglese/English), pp. 28-37 (tedesco/German)

Tony Oursler, "Talking Light", Edition for Parkett, 1996, pp. 54-55

The Now Art Book, testo di/text by Celia Lyttelton, Korinsha Press & Co., Ltd., pp. 105-108

De Rode Poort, Musem van Hedendaagse Kunst, Gand, Belgique (cat. della mostra/ex. cat.)

The Scream, Borealis 8, Nordic Fine Arts 1995-96, Arken Museum of Modern Art, Ishoj, Denmark

Margot Lovejoy, Postmodern Currents: Art and Artists in the Age of Electronic Media, Prentice Hall

"Arret sur images: Luxembourg 1996", Cafe Creme, n. 17, p. 65

Jurassic Technologies Revenant, 10th Biennale of Sydney

Christine Van Assche, "Six Questions to Tony Oursler", Parachute, n. 84, pp. 6-10

Zine: Annual Visual Collection, vol. 3, pp. 116-117

Jurgen Hohmeyer, "Apokalypse im Koffer", Der Spiegel, vol. 51,

pp. 94-96

Ferdinand Protzman, Aroma One's Own, *The Washington Post*, 21 dicembre/december

Dirk Schwarze, Oursler: "Wie Ubungen im Atelier", *Montag*, 25 dicembre/december 1996, p.19

Dirk Schwarze, "Die Klagende Puppe im Koffer", *Donnerstag*, 28 novembre/november, p. 26

1997

Celia Lyttelton & Waldemar Januszczak, *The Art Now Book*, pp. 106-108

Edward J. Sozanski, "ICA Exhibits Range From Video to Tree Trunks, *The Philadelphia Enquirer*, 21 febbraio/february, p. 36

Robin Rice, "It's Alive: Three Shows Animate th Galleries of the ICA", *Philadelphia City Paper*, 14 febbraio/february, p. 30

Kenneth L. Ames, Benjamin Ivry, Dick Kagan, Lawrence Levy, George Melrod, Dana Micucci, Stephen Wallis, "Top 100 Treasures", *Art & Antiques*, marzo/march, pp. 54-113

Vicki Goldberg, "Photos That Lie - and Tell the Truth", *The New York Times* (Arts & Leisure), 16 marzo/march, pp. 9-34

Susan Kandel, "Facing an Encounter with a Surrealist Edge", *Los Angeles Times*, 7 marzo/march, p. F20

Michael Kimmelman, "Narratives Snagged on the Cutting Edge*", The New York Times* (inserto/weekend segment), 21 marzo/march, pp. C1/C26

Adrian Searle, "Nowhere to Run", *Frieze*, n. 34, pp. 42-47

Peter Scheldahl, "Museumification 1997: The Whitney Biennial as Pleasure Machine", *The Village Voice*, 1 aprile/april, pp. 80, 81

Howard Halle, "Portraits of the Whitney Biennial", *Time Out New York*, 20-27 marzo/march, pp. 10-16

Peter Frank, "Art Picks of the Week: Tony Oursler, Lutz Bacher", *LA Weekly*, 11-17 aprile/april, p. 144

Kathi Norklin, "The Compulsion to Curate", *Woodstock Times* (Arts) 8 maggio/may, p. 14

Brook Adams, "Report From New York", *Art in America*, giugno/june, pp. 35-41

Phil Richards & John J. Banigan, "How to Abandon Ship", *FAT*, inverno/Winter 1995-96, Issue n. 2, pp. 43-35

Claudine Isé, "Tony Oursler at Margo Levin", *Art Issues*, estate/Summer, n. 48, p. 48

Matthew Ritchie, "The Edge of Vision", *FAT*, inverno/Winter 1995-96, Issue n. 2, pp. 8-10

Art in the Center: Two Discussions on Documenta X, a cura di/edited by Peter Noever, conversazione con/conversation with Catherine David, Peter Kogler, Elke Krystufek, Peter Pakesch, Gerwald Rockenschaub, Franz West, Jean-Francois Chevrier, Mike Davis, Mike Kelley, Peter Noever, Jeff Wall

Peter von Ziegesar, "A Pilgrim's Progress: Gallery Rounds", http://www.artnet.com

Michael Kimmelman, "Few Paintings or Sculptures, But an Ambitious Concept", *The New York Times* (inserto Arte/Art

insert), 23 giugno/june, pp. C9-10

Judith Bumpus, "Video's Puppet Master", *Contemporary Visual Arts*, Issue 15, pp. 38-43

Margaret Howlett, "Sound and Light", *Scholastic Art*, vol. 27, marzo/march, pp. 10-11

Paul Sherman, "ICA's Gothic Film Series is a Frightfuly Good Time", *Boston Herald*, 5 maggio/may

Gary Duehr, "'Gothic' is Spooky: ICA Exhibit Touches on Terror and Taboo", *The TAB*, 6-12 maggio/may

Christopher Millis, "Gothic Lite: Few Chills or Thrills in the ICA's 'Transmutations of Horror'", *The Boston Phoenix* (inserto Arte/Art insert), 2 maggio/may, pp.10-11

Ken Schulman, "A Touch of Class", *ARTnews*, maggio/may, p. 87

"Dark Art at the ICA", *The Boston Phoenix*, 18 aprile/april

Mary Sherman, "ICA Show Slakes First for Horror", *Boston Herald*, 25 aprile/april

Christine Temin, "At ICA, Art that Goes Bump in the Night", *The Boston Globe*, 25 aprile/april (inserto Arte/insert Art)

Roberta Smith, "The Horror: Updating the Heart of Darkness", *The New York Times* (inserto Arte/Art insert), 1 giugno/ june

Verena Leken, "Oh, gruase dich, es ist so schon", *Feuilleton*, 26 giugno/june

Andrea Gilbert, "Tony Oursler", *Arti*, vol. 33, marzo-aprile/march-april, pp. 178-182

The News Hour with Jim Lehrer, 23 maggio/may, (recensione/review Whitney Biennnial con interviste/with interviews)

Roxana Marcoci, Diana Murphy, Eve Sinaiko, *New Art*, p. 99

Marc Mayer, *Being and Time: the Emergence of Video Projection*, Contemporary Arts Museum, Texas (cat. della mostra/ex. cat.)

Kenneth Baker, "Talking Heads can Speak to Us", *San Francisco Chronicle*, 18 settembre/september

David Bonetti, "Video Effigies Dispense Empty Wisdom, Sorrow", *San Francisco Examiner*, 24 settembre/september, p. C9

Amy Stafford, "Tony Oursler: Video Drone", *Surface*, n. 11, pp. 94-95

Anthony Bond, *The Body*, The Art Gallery of New South Wales, Sydney (12 settembre/september-16 novembre/november, cat. della mostra/ex. cat.)

Engel: Engel, introduzione di/forward by Cathrin Pichler, Kunsthalle Wien, Vienna; Galerie Rudolfinum Prag (cat. della mostra/ex. cat.)

Stuart Morgan, "The Human Zoo: Stuart Morgan on Documenta X", *Frieze*, settembre-ottobre/september-october, pp. 70-77

Denis Angus, "Tony Oursler: tout le ré-pertoire des émotions", *Omnibus*, n. 21, pp. 5-7

Diane Shamash, "At the Close of the Century: Documenta X", *Documents*, n. 10, autunno/Autumn, pp. 57-60

Inter Medium Textbook, p. 44

"Organic Future", *Famous Aspect*

Damien Sausset, "L'entrepôt de l'étrange", *L'Oeil*, n. 490,

novembre/november, p. 23

"Flash Back, Flash Forward", *Artnews*, novembre/november 1997, p.190

Birgit Sonna, "Kopfe, Puppen, Videospiele", *Munchner Kultur*, 12 settembre/september, p. 16

Beate Valentin, "Es Fehlt an Gemeinsamen Inhalten", *Haudelsblatt*, 20 settembre/september, p. 4

Jean-Marc Avrilla, *Tony Oursler*, capcmusée, Musée d'art contemporain, Bordeaux, France (cat. della mostra/ex. cat.)

Der Menschliche Faktor-Das Individuum im Spiegel zeitgenossischen Kunst, Hypobank International S.A., Luxembourg France (cat. della mostra/ex. cat.)

Kenneth Baker, Tony Oursler, Paula Anglim, *Artnews*, dicembre/december, p. 168

Jean-Francois Chevrier, Catherine David, *Poletics: Documenta - the Book*, Kassel (cat. della mostra/ex. cat.)

Paul Ardenne, "Tony Oursler's Cruel Theater", *Art Press*, novembre/november, pp. 19–24

Transition: Düsseldorf 1999 (portfolio for 1999 exhibition at Kunstsammlung NRW, the Art Society, Kunsthalle Düsseldorf, the Stadtmuseum, Düsseldorf)

Zones of Disturbance, testi di/essays by Silvia Eiblmayr, John Roberts, Brian Massumi, Marc Ries, Rosi Braidotti & Ekaterina Dyogot, steirischer herbst '97, Graz (cat. della mostra/ex. cat.)

"'Poetics Project' Relives Group's Heady Days", *Los Angeles Times*, 12 dicembre/december, p. F. 28

"Exhibition Preview", *Artforum*, settembre/september, p. 66

Paul Ardenne, *Art: L'Age Contemporain*, Regard, Paris, p. 228

1998
The Secret Life of Clothes, testo di/essay by Nick Wadley, The Nishinippon, Fukuoka, Japan (cat. della mostra/ex. cat.)

Monty Di Pietro, "Never Mind the Academics", *Asahi Evening News*, 4 dicembre/december

Mysterious Voyages, Contemporary Museum, Baltimore (7 febbraio/february - 2 maggio/may)

Michael Tippett, *The Midsummer Marriage* (programma per/program for performance at National Theater, München), p. 161

Simona Lodi, *Tony Oursler*, Milano (cat. della mostra/ex. cat.)

Principali scritti dell'artista
Selected Publications by the Artist

1987
"Phototrophic", *Forehead Bd. 2*, ripubblicato in/reprinted in 1990

1988
"Vampire", *Communications Video*, novembre/november, p. 48

1990
"Phototrophic", *Illuminating Video: An Essential Guide to Video Art*, Eds. Doug Hall, Sally Jo Fifer, New York, Aperture Foundation

1991
"Triune: A Work in Progress", *Visions*, estate/Summer, p. 5

1995
"Dummies, Flowers, and Altars" (portfolio), *Grand Street: Games*, ed. Jean Stein, Jean Stein & Torsten Weisel, New York

"The Warped Vision of Bruce Nauman", *Paper*, maggio/may

1996
Tony Oursler-My Drawings, Ed. Bernhard Balkehol, Kasseler Kunstverein, Kassel (cat. della mostra/ex. cat.)

Musei e Collezioni pubbliche
Museum and Public Collections

Carnegie Museum of Art, Pittsburgh, Pennsylvania
Cincinnati Art Museum, Cincinnati, Ohio
Depont Foundation for Contemporary Art, Tilburg, Holland
Des Moines Art Center, Des Moines, Iowa
Goetz Collection, München
Musee d'Art Contemporain de Montreal
Museum of Contemporary Art, Chicago
Museum of Contemporary Art, Helsinki
Museum of Contemporary Art, San Diego, California
Museum of Modern Art, New York
Saatchi Collection, London
Tate Gallery, London
Van Abbemuseum, Eindhoven, Holland
Whitney Museum of American Art, New York

Finito di stampare nel mese di aprile 1998
da Leva spa, Sesto San Giovanni
per conto di Edizioni Charta